IMAGES OF VULNERABILITY

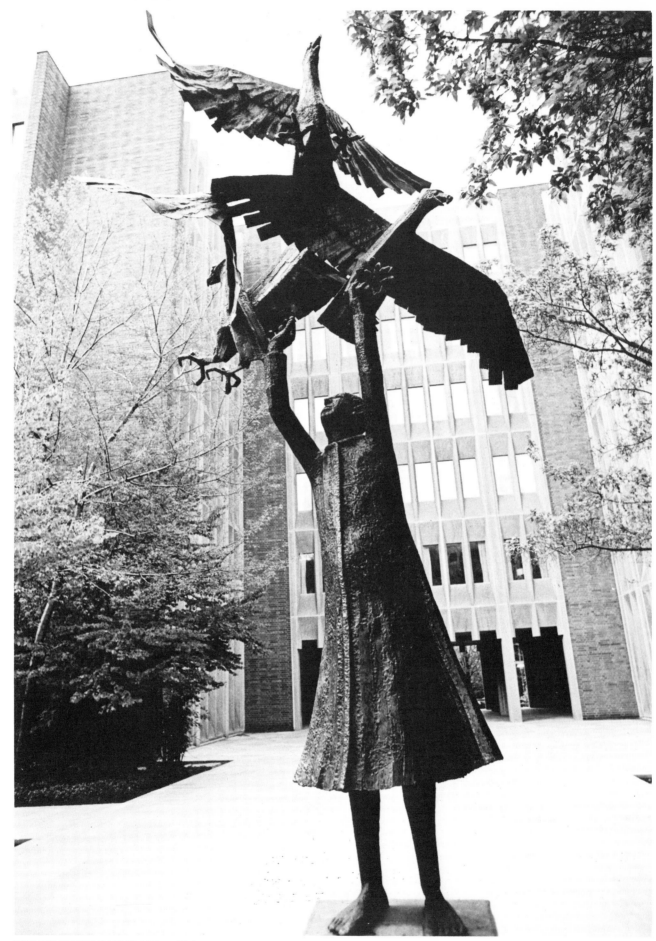

MAN RELEASING EAGLES 1973. *Welded Corten Steel. C. 12' high. (Full View)*

IMAGES OF VULNERABILITY

THE ART OF GEORGE WALLACE

GREG PETERS

 MOSAIC PRESS

Canadian Cataloguing in Publication Data

Peters, Greg.
 Images of vulnerability : the art of George Wallace

ISBN 0-88962-226-4 (bound). - ISBN 0-88962-225-6 (pbk.)

1. Wallace, George, 1920- I. Wallace, George,
1920- II. Title.

N6549.W34A4 1983 709'.2'4 C83-098977-3

Published by Mosaic Press, P.O. Box 1032, Oakville, Ontario, L6J 5E9, Canada.

Published with the assistance of the Canada Council and the Ontario Arts Council.

Typeset by Speed River Graphics.
Design by Doug Frank.
Printed and bound by Les Editions Marquis Ltee, Montmagny, Quebec.
Printed and bound in Canada.

ISBN 0-88962-226-4 cloth
ISBN 0-88962-225-6 paper

Distributed in the United States by Flatiron Books, 175 Fifth Avenue, Suite 814, New York, N.Y. 10010, U.S.A.

Distributed in the U.K. by John Calder (Publishers) Ltd., 18 Brewer Street, London, W1R 4AS, England.

Distributed in New Zealand and Australia by Pilgrims South Press, P.O. BOx 5101, Dunedin, New Zealand.

CONTENTS

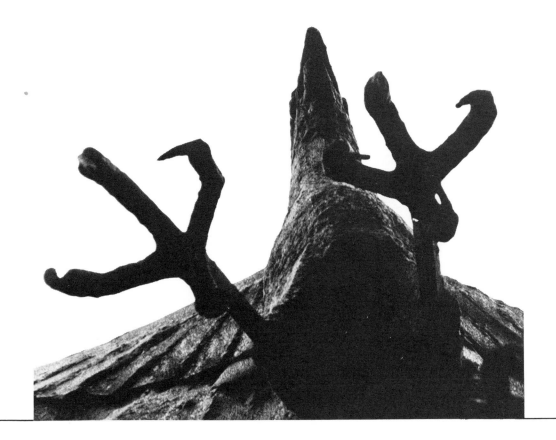

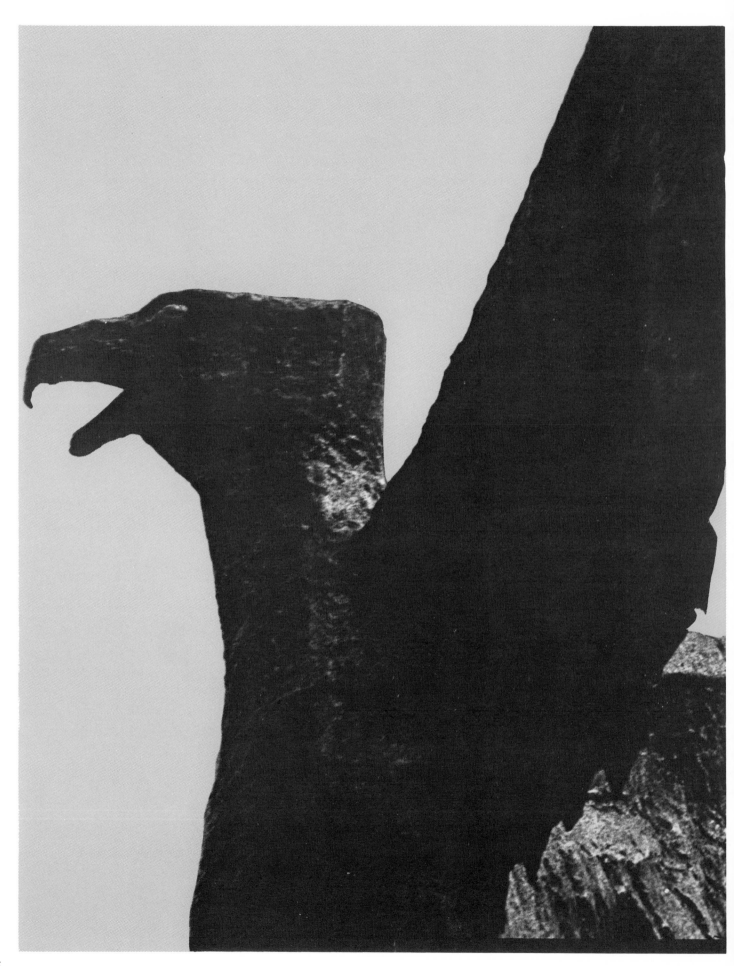

FOREWORD

With the exception of the landscapes, the following illustrations are not presented in chronological order. When I look at the work of George Wallace, certain themes appear to emerge and I have thus taken the liberty of grouping selected reproductions under general headings which are, in themselves, interconnected.

In a number of instances, I attempt to establish a relationship between George Wallace's art and Biblical, historical and literary passages. The selections of poetry either deal directly with a particular Wallace sculpture, or are included because I feel a complementary creative process at work in another art form. Any collection of artwork which displays such concern about the state of humanity as Wallace's does will share affinities with the ideas inherent in many avenues of art.

I wish to thank Wayne Allan, Rabbi Bernard Baskin and Alan Bishop, for their contributions, Bryce Kanbera and Samuel Robinson of the Hamilton Artist's Inc., for their help, and Miriam and Julius Lebow, for their much appreciated encouragement and support. I am indebted to James Chambers, David Nasby, Dan Pilling and Herman DeBruyn for the expert photography of Wallace's sculpture.

Lastly, I wish to thank George Wallace who always made himself available for my numerous rounds of questions throughout the months. This book would not have been possible without his patience and good nature.

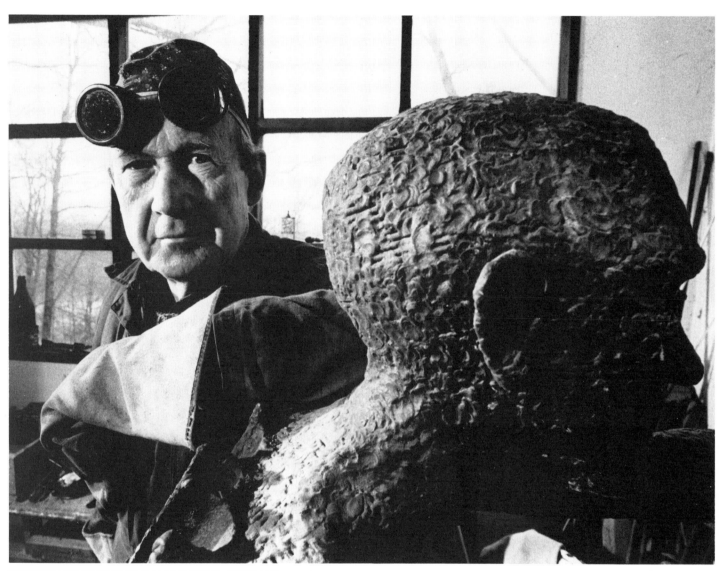

PHOTOGRAPH OF GEORGE WALLACE WITH "BENEVOLENT ANGEL" 1983.

INTRODUCTION

George Wallace was born on June 7, 1920, in South County, Dublin. An only child, he describes his boyhood in Ireland as a "rather innocent and remote life". His was the typical "bourgeois household". Apart from the usual Victorian steel engravings on the walls, there was no art in the home, and in his early schooling exhibitions of enthusiasm for this area were often greeted with mild annoyance. "We who took art, quickly learned that art and literature were subversive activities, not practiced by middle class Irishmen such as our parents and their friends, but exclusively by heroic and eccentric Frenchmen."

As a young child, George Wallace was drawn to the family gardener, a man blessed with an inventive mind, who always seemed to be constructing or carving things. He sparked a joy for creativity in the boy — the minute a drawing was completed, he would eagerly rush to the gardener's side with his latest accomplishment. To this day, Wallace maintains that the prime function of making art is the pleasure one receives from making it. Somehow, in our age, where art is regarded as either a marketable commodity by the legions of newly initiated investors, or as a mystic image of "cosmic significance" by those who view art as a form of opiate, the simple joy of creativity seems lost in "so much ballyhoo".

The drawings indicated talent and George Wallace began receiving private lessons at the age of eight. He remembers little about his first art teacher except that she painted apparently endless watercolours of flowers. As a teenager, however, he was introduced to an instructor who must have grated upon the community's rather conservative tastes, and by him was taken to visit an elderly and opinioned painter, who, as a young woman, had been taught by the French Fauvés and spent the remainder of her years in adoration of them. The interior of her early nineteenth century house was painted in daring colours and every room contained a bounty of Fauvist paintings. The bright colour schemes of these paintings had almost as much appeal for the youthful student of art as the uncomfortable effect he knew they would generate among his family members and their friends. Wallace recalls, "How fortunate I was to see my first modern paintings in a private house and not in an art gallery where one example of each would have been set out to expound some dreary notion of Art Historical development or contemporary trends".

Attending Trinity College, Dublin, from 1939 to 1944, George Wallace graduated with a degree in Philosophy. The war in Europe had no real effect upon him. Apart from food shortages and propaganda broadcasts (from both sides) Dublin was untouched by the devastation sweeping continental Europe.

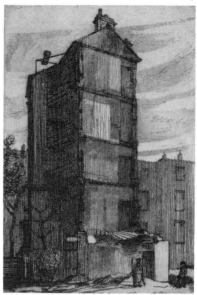

BOMBED HOTEL 1951. *Etching. 4″ × 6″.*

After the war, Wallace enrolled in the West of England College of Art, Bristol, studying techniques in oil paintings and hard ground etchings. Initially, he was influenced by the paintings of Walter Sickert and the Camden Town school. This is evident in his earliest works. In fact, until 1955, the etchings of George Wallace are rather traditional in character. *Bombed Hotel* (1951) and *Dredger* (1952) are small, conservative prints, accurately rendering detail. They have an atmospheric charm and are accomplished in their handling, but they clearly lack the emotional impact Wallace's art was soon to develop. *Bombed Hotel* may be regarded as the artist's first image of war.

DREDGER 1952. *Etching. 5¼″ × 3″.*

Within a few years, Wallace grew increasingly dissatisfied with the muted colour schemes of the Camden Town Group and their "matter of fact" landscapes lacking in symbolic quality. He turned with interest to the more subjective landscapes of Graham Sutherland, where heightened emotion leads to a "structural flattening of shape". Fortunately, England was experiencing a revival in the graphic arts in the early 1950's. John Buckland Wright and the artists centred around the Slade School of Art introduced a wide range of techniques. Aquatints, monoprints, lithography, soft grounds and deep etchings created immense artistic possibilities. By 1955, Wallace had found for them the perfect vehicle — the clay pits and workings of St. Austell and Redruth. He exhibited some of these prints in London, Dublin and Bristol.

George Wallace became interested in the early wrought and welded sculptures of Reg Butler, at about the same time, and attended a local technical school in order to learn the mechanics of welding. He came to Canada in July, 1957, and thus the majority of his work in this medium has been created here. Before moving permanently to the Hamilton area, Wallace had exhibitions at the Waddington Gallery in Montreal and the Gallery of Contemporary Art in Toronto. He became a full time staff member at McMaster University in 1960, and the first life-sized sculpture, a Lazarus, was completed the following year.

For over two decades, George Wallace has been peopling our landscapes with his creations in bronze and in welded steel. There are now over twenty of these very human figures inhabiting Southern Ontario centres, and a much larger number of comparable prints and drawings in private and public collections. Wallace has brought to Canadian art an urgently needed moral temperament. Everything in his work is either directly or indirectly formed by his concern for the complex fate of man. There is at last an artist in our country forcing us to face the essential questions.

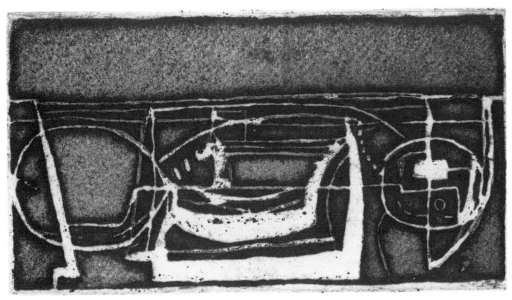

PIT WORKINGS 1956. *Deep Etching. 6½" × 3 7/8".*

Many artists today create visual images which may be interesting and innovative, but rarely do they convey anything of significance beyond the narrow confines of style and design. The art of George Wallace contains no conceptual tricks. He gives us a world without props, cut down to the essential. Throughout, there is a consistent temperament expressing itself in images which are intensely human.

Wallace's art centres on representational compositions. An artist who is as concerned about communicating the actual state of man as Wallace is, will find little comfort in abstracted dots and lines: to make form out of the mystery of existence is for him an absolute necessity. This is particularly relevant, he feels, to his sculpture. Because sculpture is on permanent display, it must assume "a more public image" than the other visual arts. Sculpture occupies space and entails a considerable capital investment, and as such, large sums of money should not be squandered on someone's personal fantasies. Hence the artist is obliged to make the life-sized image intelligible. Even the actual process of constructing a three dimensional figure draws the sculptor in this direction — "It looks at you while you go on working at it."

Wallace's creations in welded steel appear to take on a presence of their own. When I watched him at work on his recent Lazarus sculpture, welding the hot white ribbons of steel piece by piece, it was as if something uncomfortably human was beginning its life before my eyes. In a way, the mechanics of sculpting in welded steel finds one of its most suitable vehicles of expression in the resurrected spirit of Lazarus, a subject we encounter a number of times in Wallace's art.

This all too human quality of George Wallace's sculpted figures has resulted in some ironic occurrences. When the "Hanging Thief" was first exhibited at McMaster University's Wentworth Hall, an alarmed custodian, on his nightly rounds, mistook it for a student suicide victim. Within minutes, the sculpture had attracted an unlikely audience of firemen and police.

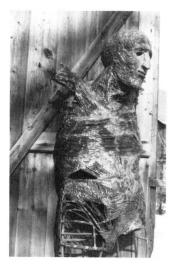

THE HANGING THIEF (Detail) 1961.
Welded Steel. 73 × 22 × 84¼".

But it is not enough to reason that these artistic creations emit such a vital life force simply because they are figurative depictions, for this element emerges from all Wallace's art, whether prints or sculpture, landscapes or portraits. We must dig deeper. The sculpture and prints repeatedly examine the dilemmas of Christ, Peter, Lazarus and a number of similar victims. There is nothing very pretty about them. Lacking any grace, they are usually small, flabby and hairless. It is difficult to imagine more physically helpless beings. These are the primary inhabitants of a fallen world, where each is a prisoner of the human condition.

Even George Wallace's landscapes express this degree of vulnerability. Formed by a combination of the artist's imagination and memory over a span of almost three decades, these hard and soft ground etchings are of the areas surrounding the British mining communities of Redruth and St. Austell, in Cornwall, where the years of burrowing into the earth for its riches has created a "landscape of sinister dark holes". The desolate earth has been cut open so often that hardly a trace of nature remains. Surreal forms, some of them disquietingly human in shape, are exposed. Thus it is as if we are given an artistic vision of an apocalyptic world, where both the earth and its inhabitants share the same fate.

As noted, biblical characters and their situations are abundantly represented in Wallace's sculpture and graphic work. The reason for this is obvious: within its covers, the Bible contains every conceivable human occurrence. From generation to generation, it has provided a collective framework of symbols and images in which the most crucial problems of our existence were scrutinized. And by tapping into this source, the visual artist could unite his art with this structure of ideas.

Modern man, however, has turned away from the Bible. It is becoming a neglected document, as obscure as any ancient mythology, and the result is that a vital chain between man and his art is being severed. In such a situation, art tends to retreat into itself — the imagery becomes too vague and personal. George Wallace counters this increasingly hermetic trend in the arts by placing his biblical figures in dramatic settings which exceed almost any need for reference. One does not require a thorough grasp of the Bible to recognize the suffering written across the faces of many of his portrayals. Painfully resurrected from his state, any of the artist's representations of Lazarus, for example, could just as easily be a terminally ill patient or prisoner momentarily yanked back into the living world from his cloistered hospital ward where he awaits his death.

From such an artistic foundation a powerful dialogue emanates: images and ideas begin to connect. In part, the impact of Wallace's art lies in his realization that the dilemmas faced by his mythological and biblical figures are even more crucial now than when they first came into being. Man has not learned by his tragedies (he simply creates bigger and more costly ones), and through the artist's connecting structures of imagery, we are made aware of these recurring processes within our history.

Contemporary events have inspired the artist to create some of his best works. The Vietnamese War, for instance, supplied the creative spark for the sculpture of the "Legless Man". Yet Wallace's art rarely aims at specifics, and the agonized despair expressed by the "Legless Man" cannot be confined to a particular war. Contemporary actions become germinating points for the depiction of a spiritual drama which stretches back to the Bible and beyond. Modern day prisoner portrayals bear an affinity to representations of Lazarus and the dead Christ, beneficiaries of systems of justice are poised in balancing acts comparable to the artist's arrangement of Adam and Eve in "The Apple Pickers". Through this process of artistic comparisons, Wallace pulls our particular actions into the timeless arena of unresolved psychological and spiritual situations. We begin to see the accelerating episodes of brutality and suffering in our world, of which we are a part, as the manifestations of an ever growing spiritual crisis.

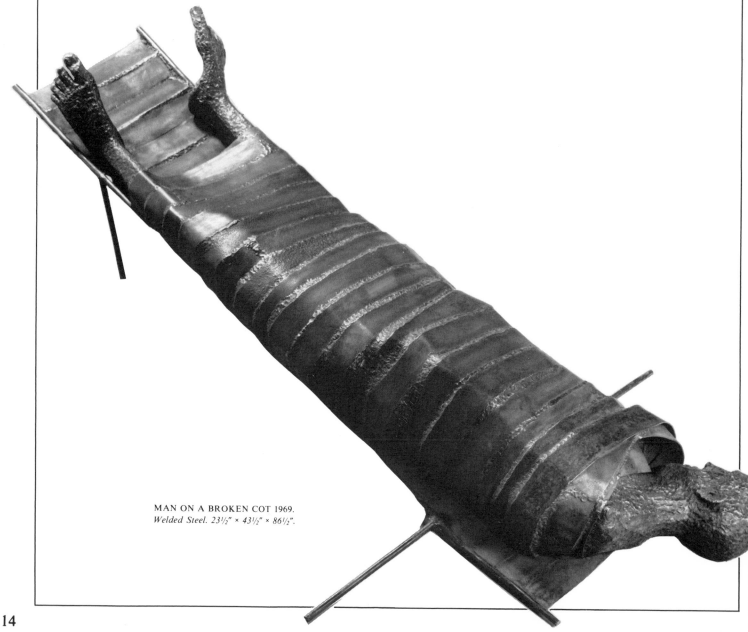

MAN ON A BROKEN COT 1969.
Welded Steel. 23½″ × 43½″ × 86½″.

On this level, a number of Wallace's works are reminiscent of the great German expressionists from the beginning of our century, and particularly comparable in both temperament and style to the prints and sculpture of Ernst Barlach and Kaethe Kollwitz. Like Wallace, these artists were deeply concerned with suffering. They certainly witnessed their fill, living in a Germany racked by poverty, world wars and the rise of a terribly destructive ideology. On the other hand, George Wallace has spent most of his life in the relatively tranquil environs of the British Isles and Canada: he has experienced none of the actual death and ruin that accompanies war. And probably because of this, Wallace's art rests upon a much wider base. He points out that, growing up in Southern Ireland, he "had no real picture of war", and from his position of remoteness from combat, each episode of brutality and devastation that the twentieth century had to offer through the years, affected him on a more internal, moral level. Ingrained within him since infancy, the entire system of justice and conduct — Wallace terms it his "boy scout honour" — was eventually questioned. Wallace's startling images derive their intensity from his ability to see beyond surfaces to the forces which continue to shape our world.

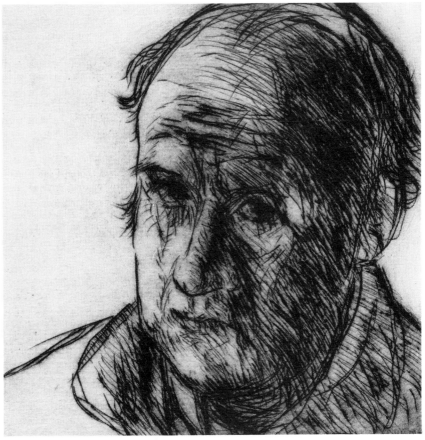

SELF PORTRAIT 1973. *Drypoint. 5″ × 4¾″.*

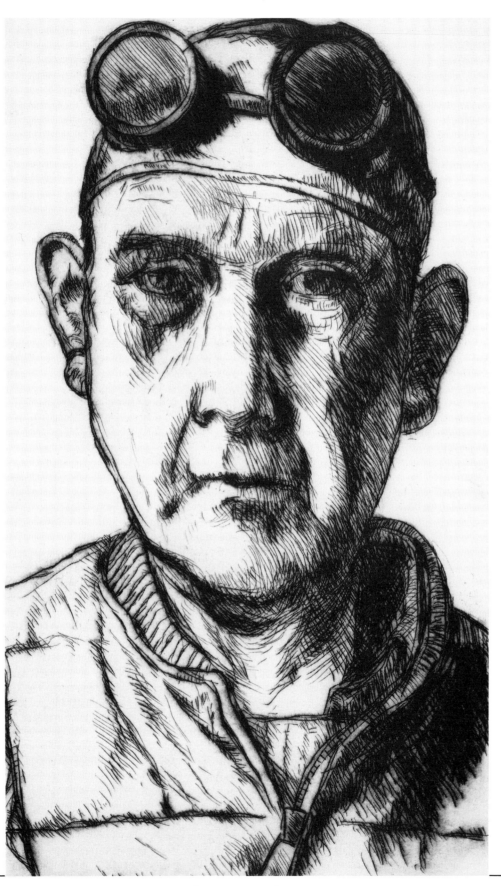

SELF PORTRAIT 1973. *Drypoint. 15½″ × 8½″.*

The expressions of these invented beings always appear to reflect back upon our way of life. The tragic portrayals of prisoners and other victims are most relevant to our time, for no matter how cruel the experience, each of them is passive and helpless. Gone is the eye-witness indignation of a Goya or a Daumier. It is as if the horrors of our actions have reached the point where they can only be regarded with resigned bewilderment. Or, are these victims, from their cells of unbearable silence, regarding us in this manner? Completely broken, they have suffered so much that even pain seems no longer possible. Perhaps the only thing that can remain on the ruthlessly disfigured face of "The Prisoner" is the question, "Why?".

Through their work, artists such as Rouault, Barlach, Dix and moderns such as Leonard Baskin have made the crisis of our existence the cornerstone for their paintings, prints and sculpture. They have shown us the human consequences of a spiritually empty and fallen world. Isn't this what we see in Wallace's depictions of Lazarus? Here is a man who has lived out all the pain and suffering in life, now hauled back to re-live the cruel joke in a body and a soul permanently scarred by death. The parallel with the half dead survivors of Auschwitz and Dachau is too close not to mention. No wonder these images strike us with their human quality.

But this fallen world contains even deeper levels, as surely as the depictions of suffering and death exist beside images of redemption and resurrection. Behind the expressions of George Wallace's Lazarus, Christ, Peter, his prisoners and other figures, within the earth of St. Austell and Redruth, and even across the map of his own face in the self-portraits, one senses a force at work. A silent mechanism, quite independent of our own desires, is forever present. This sets these images on a remarkable plane, where even the representations of death are transformed by this force. In the art of George Wallace, the dead are never just dead.

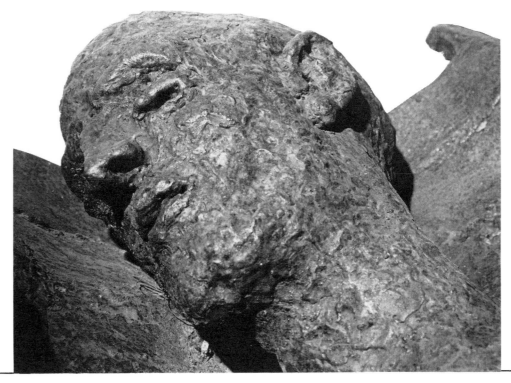

MAN ON A COT 1969. *Welded Corten Steel. 18" × 28" ×70". (Detail).*

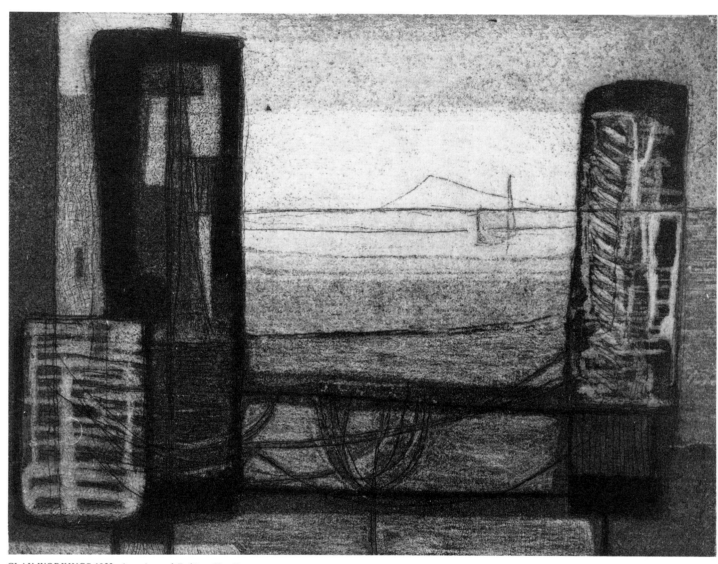

CLAY WORKINGS 1955. *Aquatint and Etching. 8″ × 6″.*

ST. AUSTELL AND REDRUTH LANDSCAPES

For over two hundred years, the area of St. Austell, Cornwall, has been mined for its china clay deposits. In its natural state, the earth somewhat resembles mortar. By hosing and repeated filtration, the clay is freed from the silica and other course ingredients, then dried and cut into blocks. Brilliant white cones of silica deposits appear above the working pits and the china clay runs into ponds, turning into a turquoise, opalescent colour.

On occasion, you run across columns of granite in the pits which have defied any sort of erosion process. This is the case in "Clay Workings", where two granite structures dominate the picture. As well, in the foreground are lines and ghostly forms signifying abandoned workings. A fascinating aspect of this area is that it has been worked for so long that the fossil remains of long dead operations dwell in the landscape. In the far background is a pyramid of silica deposits.

The countryside surrounding Redruth, in Cornwall, is a tin and copper area. Tunnels are cut into cliff walls, down into the earth, or even under the ocean floor, and have been since the end of the seventeenth century. Wallace speaks with both horror and amazement concerning the remnants of elevator systems, constructed of dangerous balancing beams, which carried the men down the pit shafts and back up again, all this in total darkness.

One senses the violence and the danger that once was in the Redruth mines in a lithograph entitled "Disused Pit Shaft". Although there is no elaborate ornamentation here, something of the mood of Piranesi's "Prisons" comes to mind. This is a cemetery of sinister machine forms which once moved up and down and across, tearing into the earth and carting its human cargo from one black point to another. In the dead silence, you almost expect the slumbering machinery to begin their motions again.

For hundreds of years, St. Austell and Redruth have been subjected to the same situation. Operations are financed, the landscape ripped apart for its minerals, and then when either the money or the vein dries up the workers move on, leaving only non-salvageable equipment and a new set of wounds within the land itself. The depictions of these landscapes are not dissimilar to the other illustrations in this book: in each is the element of vulnerability. The earth is as victimized as Lazarus, Peter, Christ or any other figure Wallace examines in his art.

Yet a mysterious beauty begins to emerge. You cannot help but be amazed by the patterns created by the years of devastation and the manner in which the artist interprets them. The landscapes are now so far removed from nature, from our usual comprehensions, that they have a meaning and a life of their own.

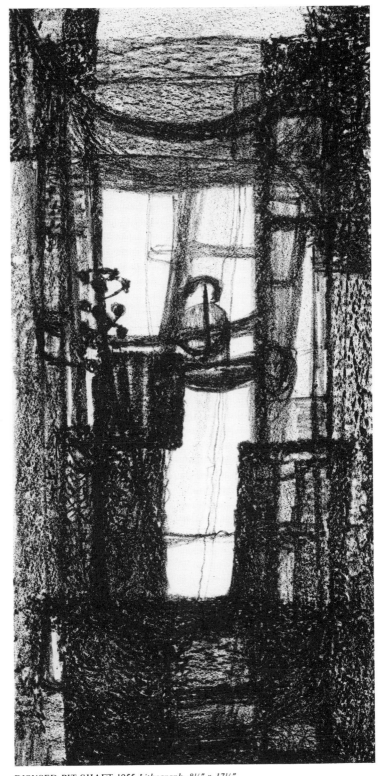

DISUSED PIT SHAFT 1955. *Lithograph. 8¼″ × 17¼″.*

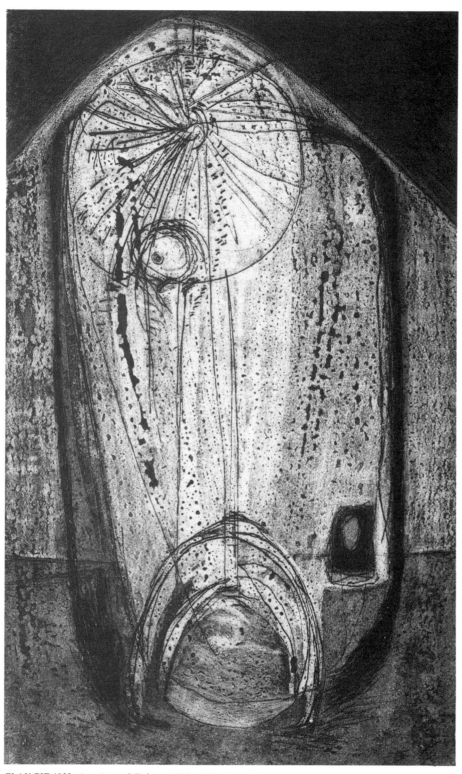

CLAY PIT 1955. *Aquatint and Etching. 11¾″ × 6¾″. Second State.*

An other sense tugs at us:
we have lost something,
some key to these things
which must be writings
and are locked against us
or perhaps (like a potential
mine, unknown vein
of metal in the rock)
something not lost or hidden
but just not found yet

that informs, holds together
this confusion, this largeness
and dissolving:

not above or behind
or within it, but one
with it: an

identity:
something too huge and simple
for us to see.

—Margaret Atwood,
From, *A Place: Fragments*

UNTITLED 1955. *Soft Ground Etching. First State in Blue and Black. 11¾" × 9½".*

As the artist expands from the initial representations, a private landscape begins to form in which a subjective expression takes hold over any purely figurative depiction. Sculptural, austere shapes are compared and contrasted to produce works of immense mystery.

UNTITLED 1955. *Soft Ground Etching. Second State in Black, Green, Yellow and White. 11¾″ × 9½″.*

When several states are examined side by side, it becomes apparent that Wallace is restructuring each scene from the actual to the imaginary. Thus, in the most abstracted etchings, the rock becomes flattened into large, monumental forms, forcing us to focus our attention less on the setting and more on each mysterious shape.

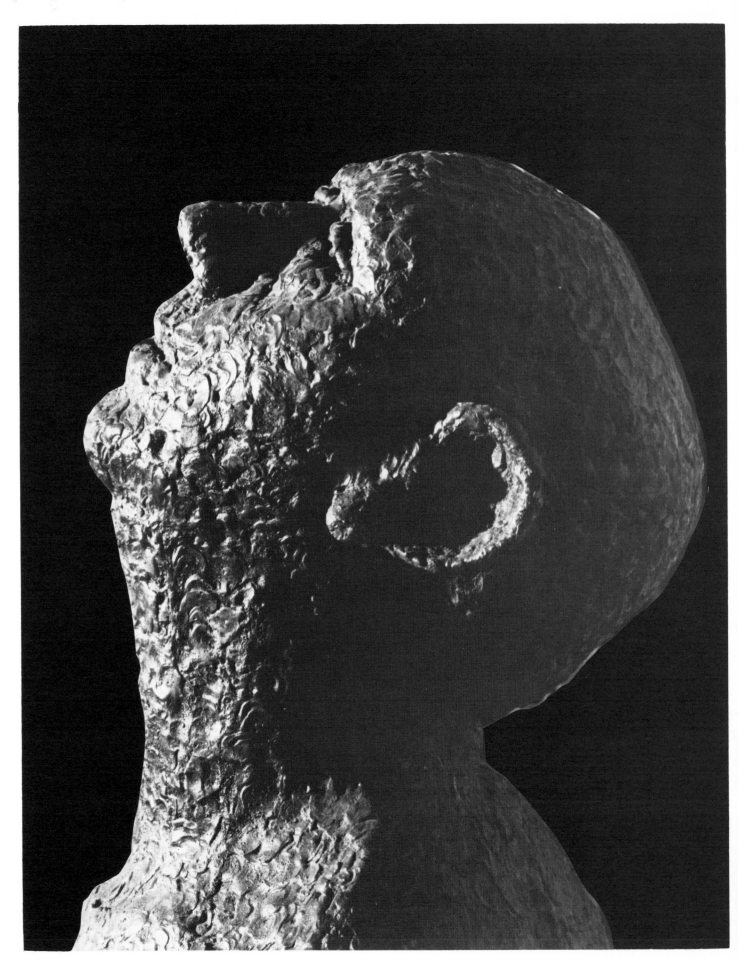

26 DAEDALUS (Detail) 1962. *Welded Steel. 67½" × 22" × 19 11/16".*

FALLING ANGELS

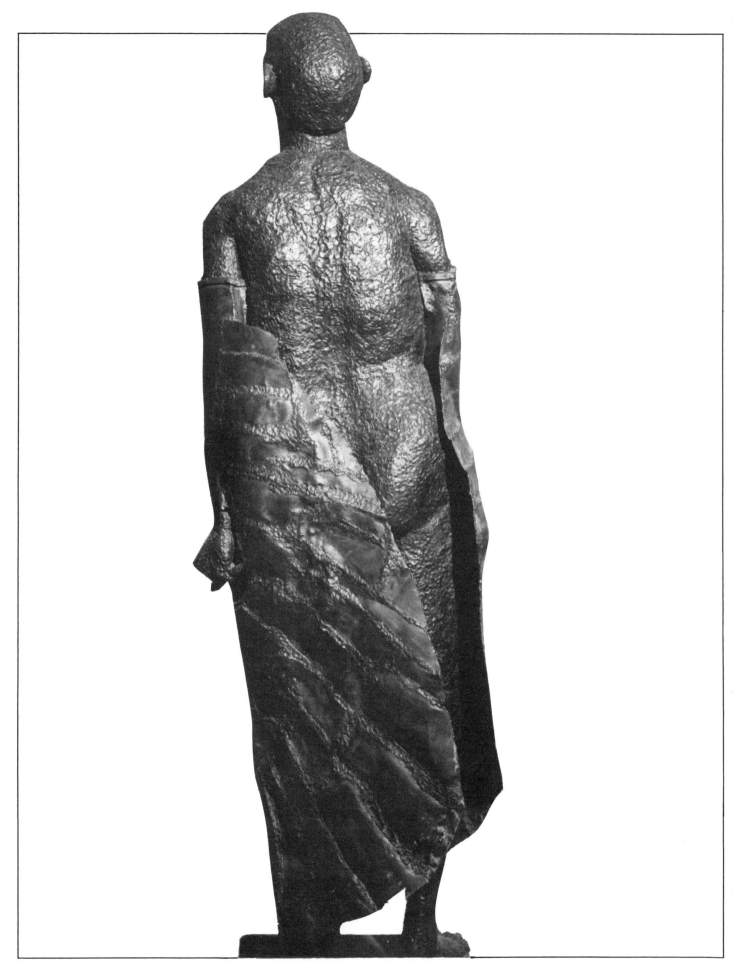

DAEDALUS 1962. *Welded Steel. 67½″ × 22″ × 19 11/16″.*

In myth, Daedalus was a master craftsman. Practically no device or invention fell outside his abilities: his statues were so perfectly constructed that they would move at his command. A fit of jealousy prompted him to murder Talos, an apprentice who threatened to surpass him, and only by his extreme daring and ingenuity did Daedalus manage to escape punishment. Seemingly such a gifted individual could operate outside the boundaries normally allocated for the rest of mankind.

Daedalus lived by systems. No matter what he put his mind to, the end result would be a mechanism of flawless working order. Later, to escape from Crete, he even turned the human body into a wonderful machine, making a pair of wings for himself and another for his son, Icarus. Gazing upwards, fishermen, shepherds and ploughmen mistook Icarus and Daedalus for gods, as they flew gracefully away from their island prison.

In George Wallace's sculptures of welded steel we see Daedalus not as the triumphant technologist, but at the moment of his great despair. Despite fatherly warnings, Icarus had soared too close to the sun, melting the wax on his wings and thus falling to his death in the ocean below. For a brief moment, father and son had been as Gods; now we see a pathetically small, squat figure whose cumbersome wings make him look incapable of any heavenly movement. Painfully gazing at the sky, he witnesses the death of his son. Perhaps the realization of his own human deficiencies also begins to dawn upon him. In a way, Daedalus was a victim of his own invention.

DAEDALUS (Detail) 1962.

Twentieth century technology has made the statues of Daedalus come to life. Self correcting machines now possess the scientific capability to accomplish this ancient myth. For well over a century, men have marvelled at the beneficial possibilities of our technical innovations. Many have rushed to the bandwagon of 'progress' which has continually pledged to deliver a utopia of enlightenment by these means. A quick stroll down any industrial city street is enough to show that the wagon lost its way somewhere. And our endless chain of wars also illustrates that technology delivers previously undreamed of 'improvements' in the taking of lives. We possess the means to destroy ourselves in a number of efficient ways. Since we are the true heirs of Daedalus, there is no reason to believe that we will not share his fate.

Wallace's 1968 drawing entitled "Design for a Wall Relief on the Theme of Technological Progress", is a riveting image of man trapped by his technological achievements as surely as if they were prison bars. Four figures are seen among the closely grouped columns of hardware; two are crushed between these threatening structures, while the remaining pair are hopelessly squashed within them.

How have we reached the state of affairs where a depiction such as this becomes valid, where the very process of mechanization has itself become an uncontrollable machine? Technology is but a symptom, the fault lies in our

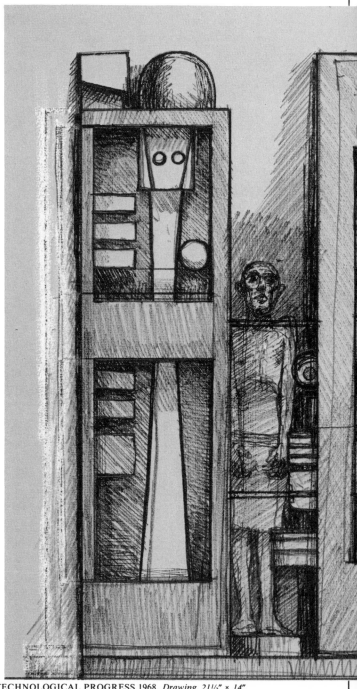

DESIGN FOR A WALL RELIEF ON THE THEME OF TECHNOLOGICAL PROGRESS 1968. *Drawing. 21½″ × 14″.*

dangerous notion that 'progress' must continue on unchecked no matter what the cost. We are thus victims of a completely arbitrary force which is capable of enslaving us to the systems of machinery we once viewed as our saviours.

One possible conclusion is here presented. This design is strongly suggestive of wall reliefs found in ancient Egyptian tombs, where the symbols of a dead language crowd round each figure, as the unidentifiable machine parts pin down the men, the woman, and child in this drawing. These then are the mummified bodies of a civilization long since destroyed.

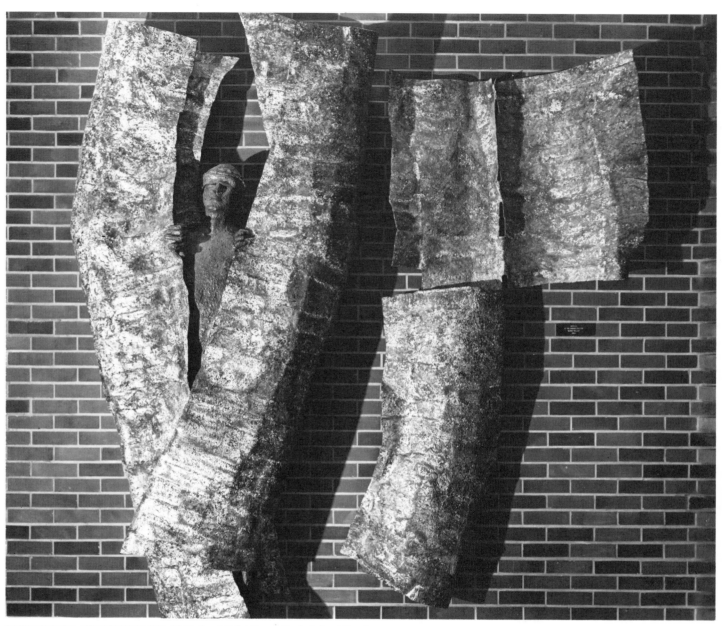

EDUCATIONAL EXPERIENCE 1969. *Welded and Nickel Brazed Steel. C. 8' × 10" wide.*

The "Design for a Wall Relief on the Theme of Technological Progress" was carried no further than the initial drawing. Wallace, however, employed comparable elements of entrapment in the 1969 sculpture entitled "Educational Experience". From a dark crevice surrounded by shining metal sheets, the upper body and blindfolded face of a man is visible. Perhaps the artist is suggesting that education may open this person's eyes and permit his escape. On the other hand, the sculpture might indicate that the same unseeing notions which govern our misuse of technology, run through all our systems, whether they be law, politics or education. Far from opening this person's eyes, the educational establishment may have made his obstacles more impenetrable. He might get out, then again, he might not.

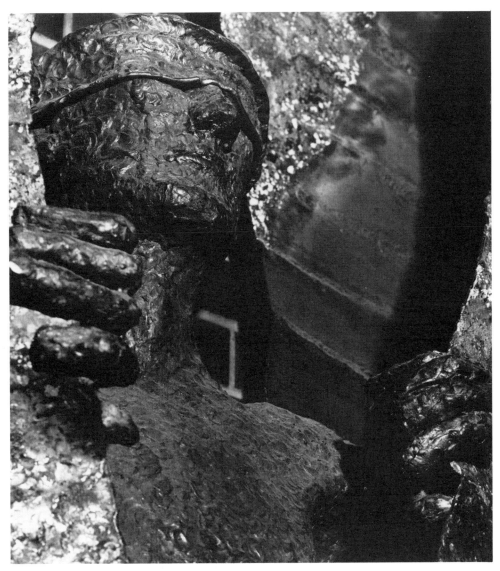

EDUCATIONAL EXPERIENCE. Detail.

"Fortune maltreats those who court her. Efforts to rise she rewards with hot air and those who have risen she punishes by downfall."

Commentary from Goya's Caprichos #56.

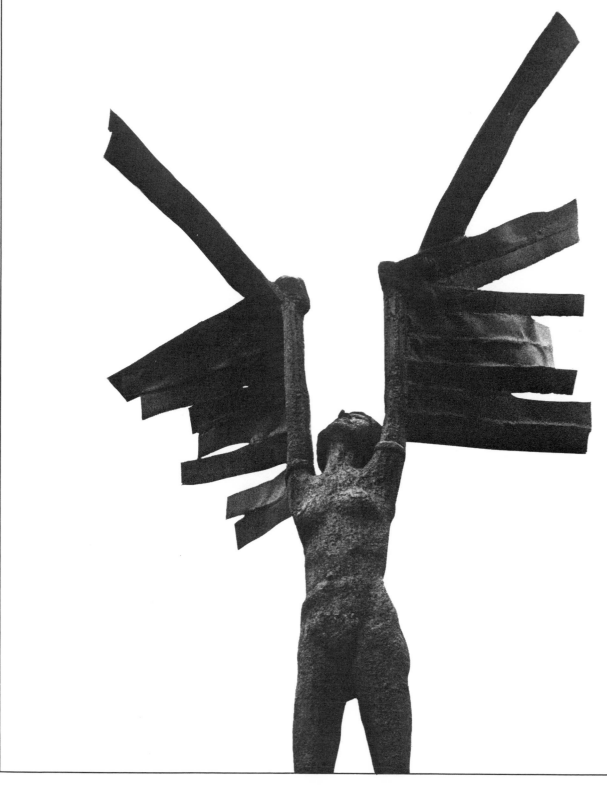

EDUCATIONAL EXPERIMENT 1969. *Welded Corten Steel. 24' high.*

This teetering construction of corten steel, obviously provides a comical comment on the process of education. The lower figures (instructors and administrators) create an unstable pyramid of support for a young woman who holds her Daedalus-like wings high with pride and confidence. Her mock heroic pose suggests she has probably made her way through all educational requirements and is about to graduate. However, the amount of back-breaking toil it takes to raise her to such a height hardly seems worthwhile, and it will not take much to topple this precarious balance and bring another aspiring angel down.

Both "Educational Experience" and "Educational Experiment" are on permanent display at one of our institutions of higher learning. It is amusing to think of the daily parade of students and teachers shuffling past these works.

Rationalists, wearing square hats,
Think, in square rooms,
Looking at the floor,
Looking at the ceiling.
They confine themselves
To right-angled triangles.
If they tried rhomboids,
Cones, waving lines, ellipses —
As for example, the ellipse of the half-moon —
Rationalists would wear sombreros.

Wallace Stevens,
from *"Six Significant Landscapes"*

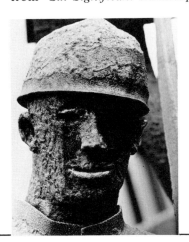

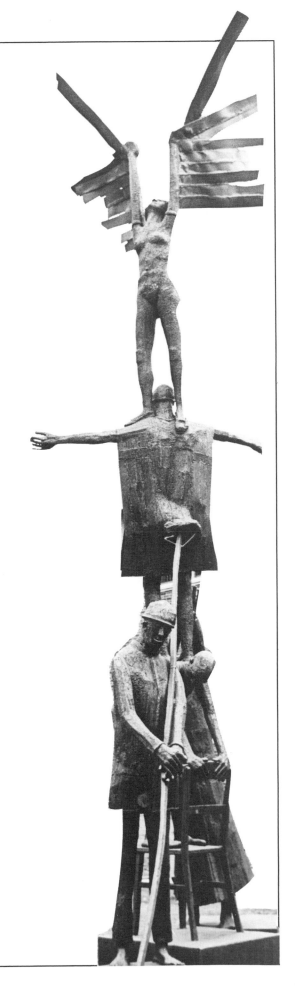

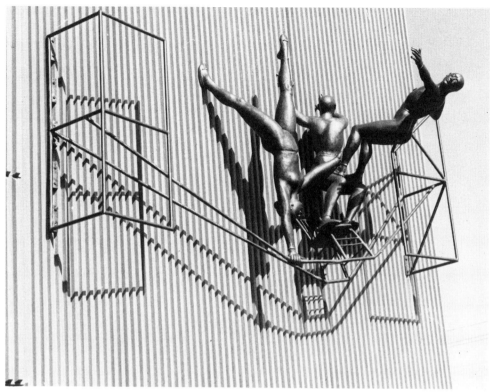

THE BALANCING ACT 1980. *Bronze. 9' high by 15' wide.*

In 1980, George Wallace was commissioned to make a bronze sculpture for the new family law court in Milton, Ontario. "The Balancing Act" provides an interesting comment on justice for anyone who approaches the building. The artist relates that "The Balancing Act" was made "when we learnt the R.C.M.P. had been misbehaving itself", and generally illustrates that "justice is a risky business". Here, the scales of justice symbol has been transformed into a dizzying balance on tightropes, where a mother, father and son are forced to assume extreme and dangerous positions in order to counter one another's movements. Only a constant, frantic struggle maintains the equilibrium.

You cannot help but become aware of the discrepancy between the static, uninviting walls and the precarious movements of the three bronze figures. It is to be hoped that the institution housed behind this exterior can give essential aid to the 'balancing act' of this family unit.

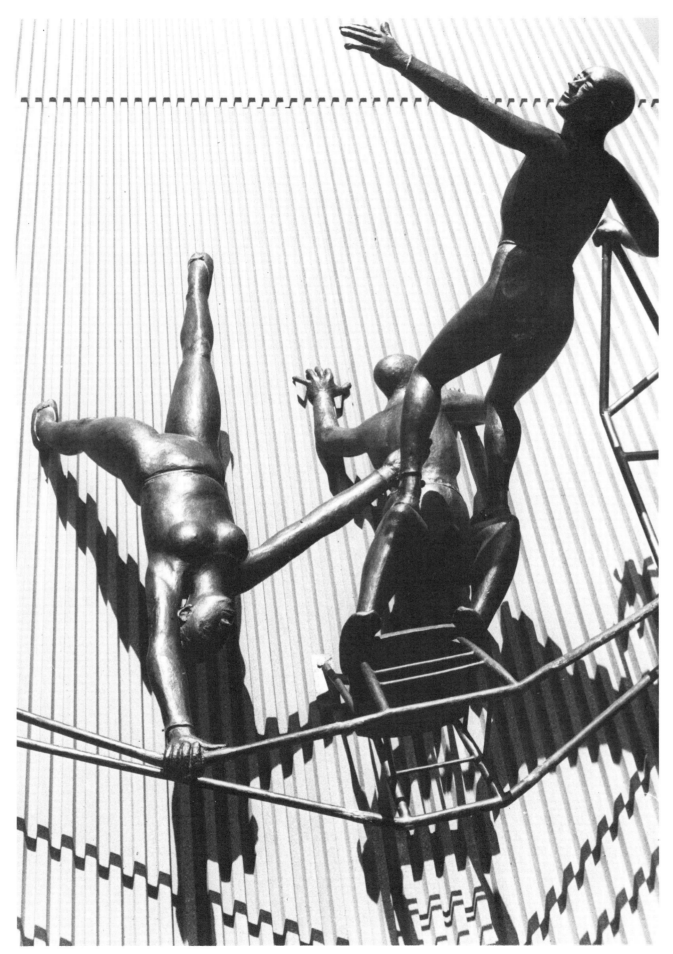

THE BALANCING ACT.

And the serpent said unto the woman, Ye shall not surely die:
For God doth know that in the day ye eat thereof, then your eyes shall be opened,
and ye shall be as gods, knowing good and evil.

Genesis 3, Verses 4 & 5

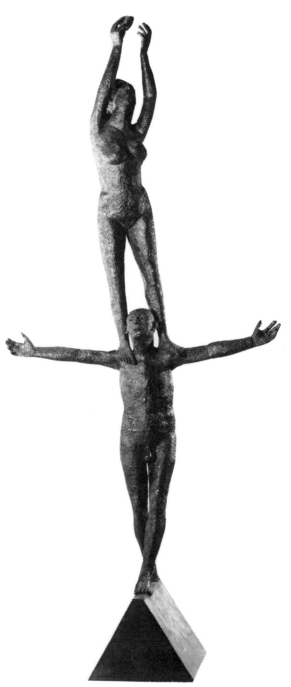

THE APPLE PICKERS 1974. *Welded Steel. 151″ × 66½″ × 29½″.*

George Wallace has here depicted the most famous and fatal balancing act. The apple has just been selected, the fall is but a moment away. Adam and Eve are poised like acrobats, illustrating their ill fated aspirations in physical terms. (The last three sculptures, in fact, have a circus quality about them. You are left with the distinct impression that, from time's beginnings in Eden, all our man-made desires and activities may be viewed as clownish travelling shows. Even Daedalus appears somewhat like the little, fat man shot from the cannon.) It is obvious that the inability of Adam and Eve to maintain their earthly paradise and the tragedy which struck Daedalus are one and the same: in both cases they tried to "be as Gods". The warning for those of us obsessed with life's parade is clear enough.

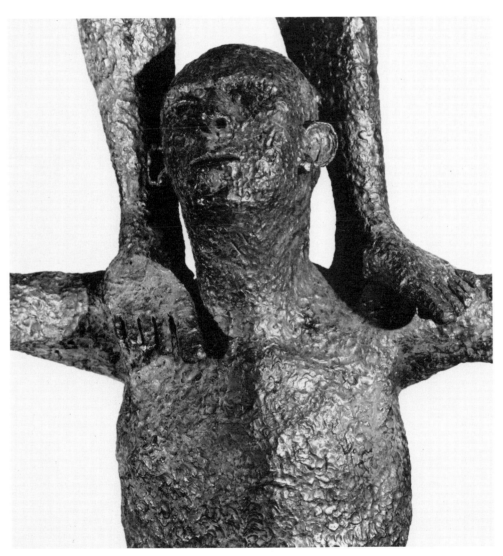

THE APPLE PICKERS. Detail.

PRISONERS

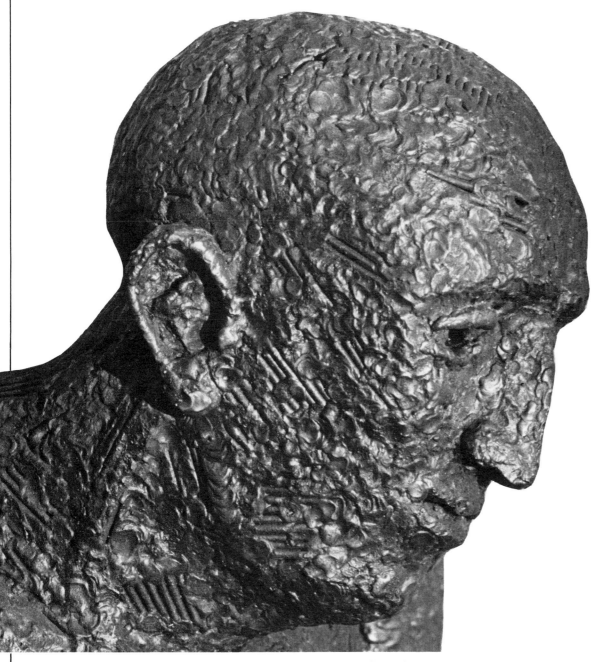

THE HANGING THIEF 1961. *Welded Steel. 73" × 22" × 15".*

In a way, the characters and their situations within this section are an extension of the depictions from the previous chapter. Wallace's art continues to centre on the themes of victimization and vulnerability in light of our inherent limitations as a species. We have viewed, however, victims, whose predicaments are largely of their own making: now, in a more painfully personal way, we will see victims forced into conditions beyond their control. The first circumstance permits either lamentable or comic artistic developments, the last, only tragic. These prisoners, whether from our social or religious history, are among the artist's most hauntingly human images.

Now Peter sat without in the palace: and a damsel came unto him, saying, Thou also wast with Jesus of Galilee.
But he denied before them all, saying, I know not what thou sayest.
And when he was gone out into the porch, another maid saw him, and said unto them that were there, This fellow was also with Jesus of Nazareth.
And again he denied with an oath, I do not know the man.
And after a while came unto him they that stood by, and said to Peter, Surely thou also art one of them; for thy speech bewrayeth thee.
Then began he to curse and to swear, saying, I know not the man. And immediately the cock crew.
And Peter remembered the word of Jesus, which said unto him, Before the cock crow, thou shalt deny me thrice. And he went out, and wept bitterly.

Matthew, Chapter 26, Verses 69-75.

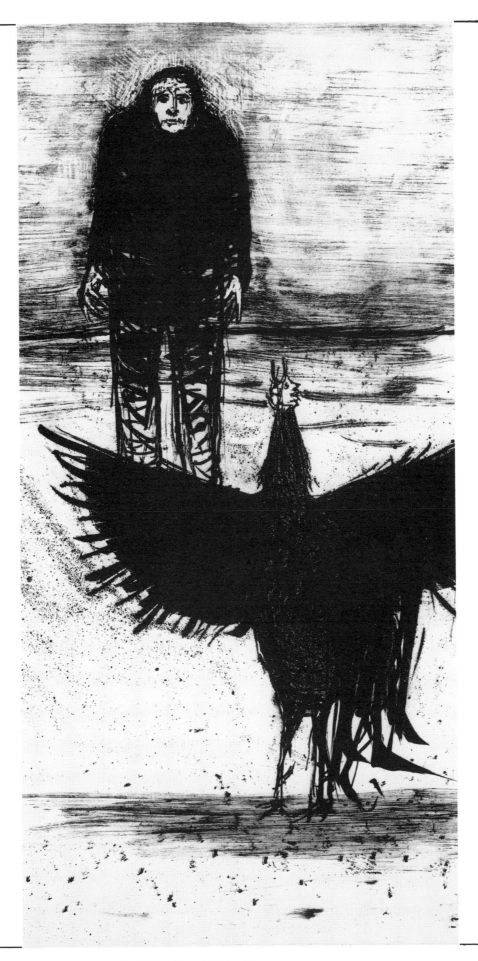

PETER AND THE COCK 1956. *Lithograph. 18¼ × 9″.*

As with all the other prisoners or victims in this chapter, Peter is visually portrayed in an atmosphere of constricting stillness. The previous lithograph shows the cock crowing in the foreground. Behind it, Peter is riveted to the spot by the dawning of his tragic revelation that he too has played his part in the drama leading to the crucifixion of Christ. Although Peter was Christ's most faithful disciple, and thus the man nearest to God, his betrayal had been foretold. He is swept up in the inevitability of things. Even the image of the cock portrays this, as it sounds off like some mad mechanism of an alarm clock.

Above all, the denial indicates that despite Peter's efforts, he is of the earthly and not the heavenly kingdom. Thus, in the lithograph, Peter's thick body seems planted in the desert landscape. And, in the soft ground etching (opposite), Peter stands motionless, his eyes fixed on the bird. Separating them is a thorn bush, its branches strongly reminiscent of both Christ's crown of thorns and a barbed wire fence. He is as much a captive as the etched depiction of "The Prisoner", whose face appears to us from behind his cage.

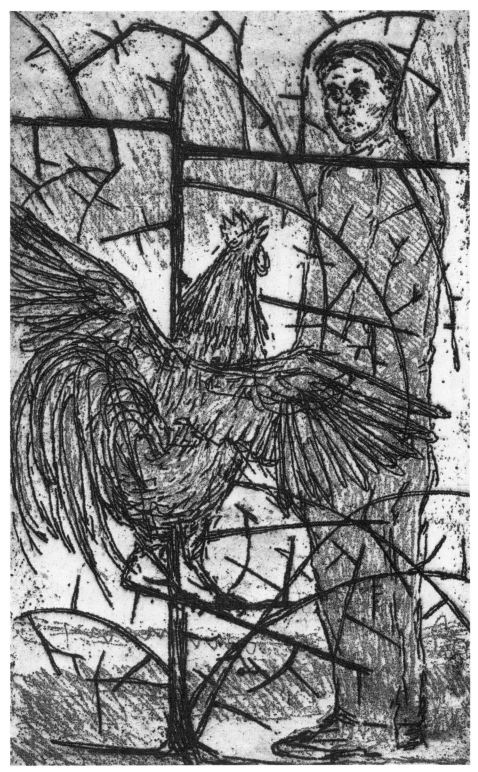

PETER AND THE COCK 1956. Hard and Soft Etching. 10″ × 5¾″.

In this final amazing etching, we view the cock crowing atop Peter's head. Against the uneasy, desolate landscape, Peter appears to be almost crushed by the bird's weight. His head is pushed into his body and his arms and chest have become one rounded thickness; no man could be more bound to his earthly state.

"Can it be we are not free? It might be worth looking into."

—Samuel Beckett, Molly

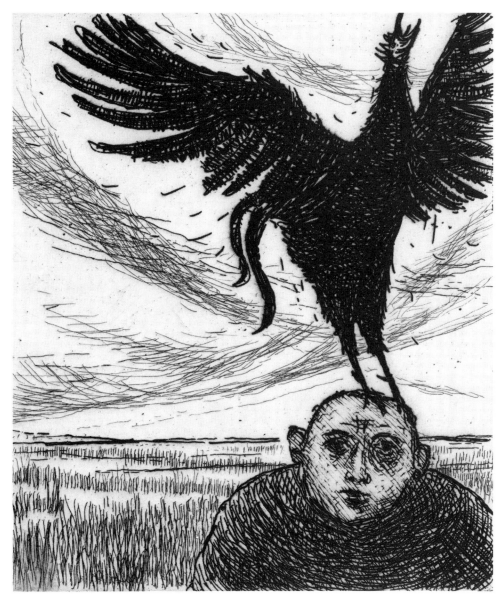

PETER AND THE COCK 1957. *Etching. 6¼″ × 5½″.*

Lazarus is another key figure in Wallace's art. Besides two sculptures, representations of him exist in drypoint, monoprint, woodcut and deep etching. The compelling expression of Lazarus is paramount in most of these works. According to the artist, the expression is enigmatic, indicating his "doubt about whether he is going to be willing to join us all." In a manner of speaking, Lazarus is Wallace's supreme symbol of victimization and vulnerability. For it is not Christ's miracle that is portrayed, but more often the state of Lazarus as he is summoned from death and decay. Lazarus is offered no choice in his resurrection. His life, even his death, is not in his control.

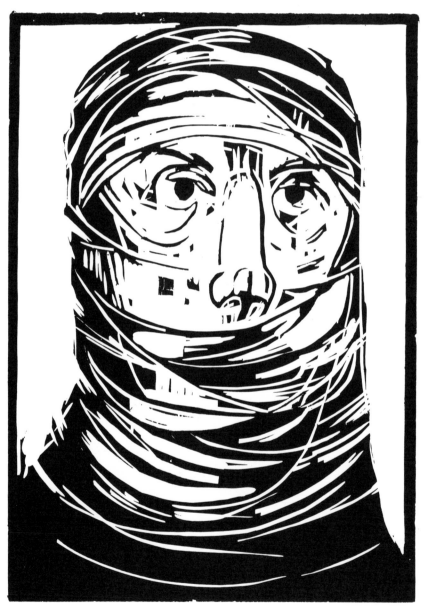

LAZARUS 1961. *Woodcut. 16½″ × 11½″.*

"To saddle me with a lifetime is probably not enough for them, I have to be given a taste of two or three generations. ...If I ever succeed in dying under my own steam, then they will be in a better position to decide if I am worthy to adorn another age, or to try the same one again, with the benefit of my experience. ...the soul being notoriously immune from deterioration and dismemberment.
Samuel Beckett, The Unnamable

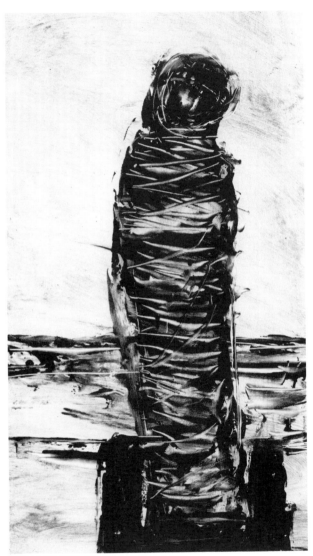

LAZARUS 1968. *Monotype. 14¾″ ″ 8 3/8″.*

Dying,
Is an art, like everything else.
I do it exceptionally well.

Sylvia Plath, "Lady Lazarus"

This is the artist's first major piece of figurative sculpture, completed in 1961. George Wallace was then living in Oakville, Ontario, between the lake and a railway line. While walking along the tracks one day, he came across a coil of metal strapping. (Wallace relates that railroad tracks and junk yards are often treasure troves of raw materials for the artist working in the medium of welded sculpture.) The long coil provided the creative spark for the head to foot wrapping of "Lazarus", one of Wallace's most moving sculptures. Standing life-sized, the tight wrapping encases Lazarus to the point where movement appears almost impossible. Half-man, half-cocoon, he looks upward in pain and confusion.

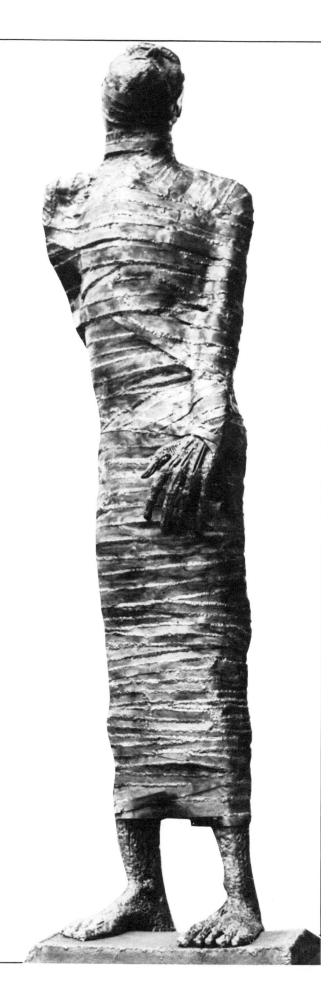

LAZARUS 1960. *Welded Steel. 73" × 18¾" × 14".*

50

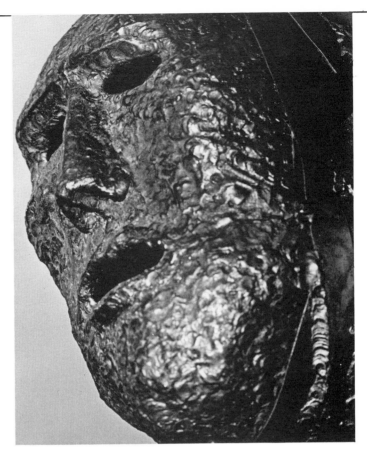

LAZARUS. Detail.

Yet George Wallace's most recent sculpture depicts Lazarus breaking free of his larval graveclothes, his arms blissfully outstretched. If Lazarus can represent the agony of death in life, he can also become the resurrection of life from death. An apparent paradox stands at the core of Wallace's art: the living are never free from death and the dead never cease living.

And when he had thus spoken, he cried forth in a loud voice, Lazarus, come forth.
And he that was dead came forth, bound hand and foot with graveclothes: and his face was bound about with a napkin. Jesus saith unto them, Loose him, and let him go.

St. John, II. Verses 43 &44.

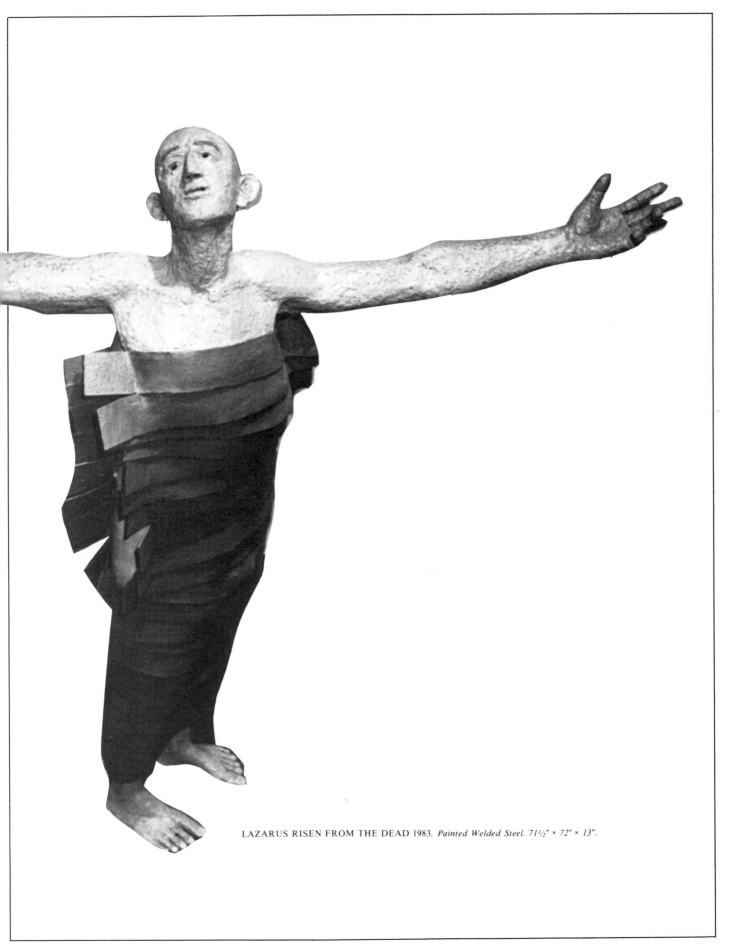

LAZARUS RISEN FROM THE DEAD 1983. *Painted Welded Steel. 71½″ × 72″ × 13″.*

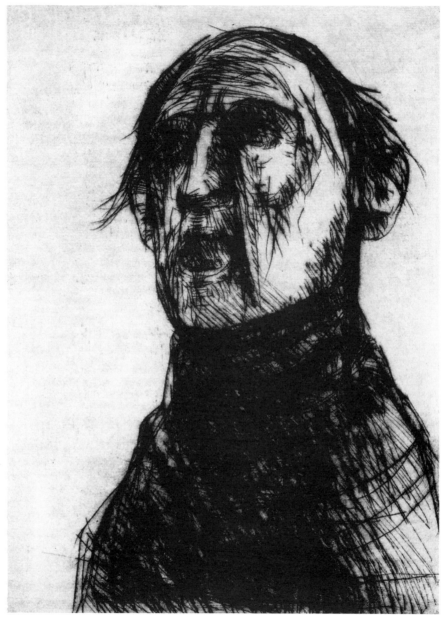

LAZARUS WAKES 1975. *Drypoint. 12″ × 8 5/8″.*

Before me floats an image, man or shade,
Shade more than man, more image than a shade;
For Hades' bobbin bound in mummy-cloth
May unwind the winding path;

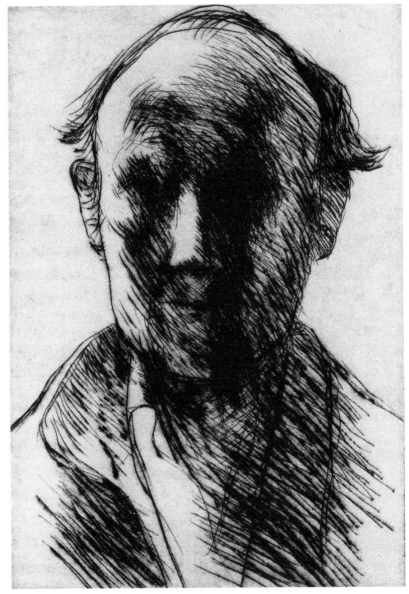

SELF PORTRAIT 1975. *Drypoint. 8 7/8" × 6".*

A mouth that has no moisture and no breath
Breathless mouths may summon;
I hail the superhuman;
I call it death-in-life and life-in-death.

W.B. Yeats, from "Byzantium"

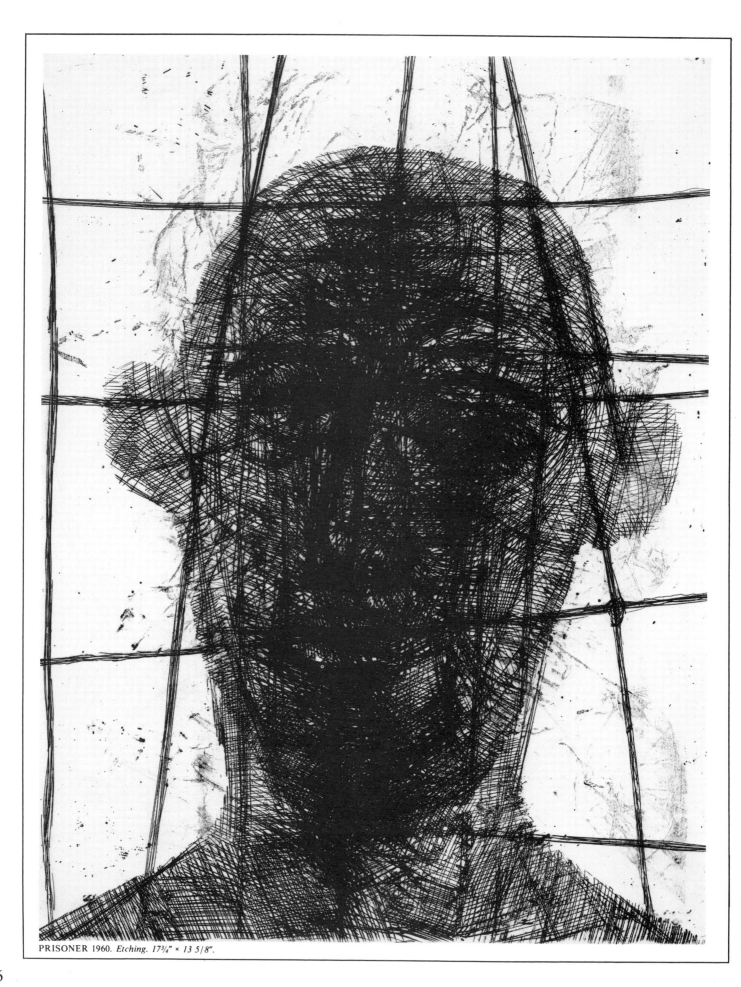

PRISONER 1960. *Etching. 17³/₄″ × 13 5/8″.*

For well over twenty-five years, George Wallace's figurative prints have largely dealt with prisoners. Specific wars and other hostilities usually furnish the inspiration, however, the completed work becomes a universal image of suffering inseparable from his religious depictions. For example, the well known 1960 etching of "The Prisoner" (employed as a poster by Amnesty International) portrays a man's face from behind a fence. His head is partly obscured by a mass of cross hatching and deep, disturbing lines. Completely broken, his fixed gaze indicates that he is beyond the point of all hope. These lines are also to be found in the drypoint of Lazarus and even in one of the artist's self portraits (pp 54 & 55).

What is particularly disturbing, to we who sit in our secure Canadian homes, is that these victims are all gazing out towards us. Being inhabitants of this earth, we must share the responsibility for their fate. The prisoners are dying for our sins as surely as Christ did.

we cannot close our eyes
we are old for our years
we are bald as babies
I am looking at you
we are old for our years
we cannot close our eyes
we are looking at you
I cannot close my eyes
we are looking at you
we are looking at you

smiling sadly out of the dusk
of their suffering

Alan Bishop, "Behind the Wire" (excerpt)
After George Wallace's "The Prisoner"

This grouping of graphics has this in common: suffering is conveyed not by an action nor a condition as much as by actual expressions on faces. This is a definite departure from, for instance, Goya's series of prisoners, where men are either garrotted or bound hand and foot in their squalid cells. A few strands of wire fencing is all that separates us from "The Prisoner". It is in the face where we see the hell of his captivity. These are portraits whose intense expressiveness make us think of that other great artist of suffering, Georges Rouault.

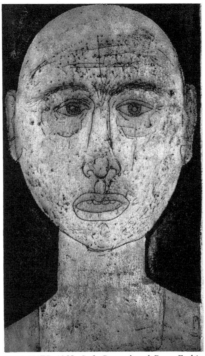

PRISONER 1955. *Soft Ground and Deep Etching.*
11¾" × 6 5/8".

But there is a tragic image which surpasses even "The Prisoner". A 1961 print, entitled "The Burnt Man", illustrates the head and neck of a fire victim. Deep etching renders a horrifying charcoal-like texture to the thick lines which make up the skin and bone structure. To fully understand this print, it is necessary to view an earlier work, "Man in a Helmet" (1956), where similar etched lines are utilized to portray the effects of burning. Wallace relates that he was intrigued by a photograph in a 1940's issue of *Life Magazine* of the burned and severed head of a Japanese soldier — the victim of a flame thrower. The heat had been so extreme that the helmet became affixed to the charred skull. As a trophy of war, an American crew placed the head on top of their tank. Thus "Man in a Helmet" and "The Burnt Man" may be regarded as grim reminders of the inhumanity of war. Commenting upon episodes such as this, Wallace states, "Wars and bloody minded tyrannies have remained a consistent part of our mental landscape."

Every century has had its atrocities. What sets the "mental landscape" of our times fundamentally apart, however, is its method. The mass extermination of Jews in German prison camps was made possible only because killing became part of the system. First, through starvation and regulated forms of torture, the victims were dehumanized into animals, into dumb brutes. At this point, many a 'decent' man could operate the gas ovens. It is significantly less difficult to execute the man whose face Wallace depicts in his "Prisoner" than the man who is still unbroken.

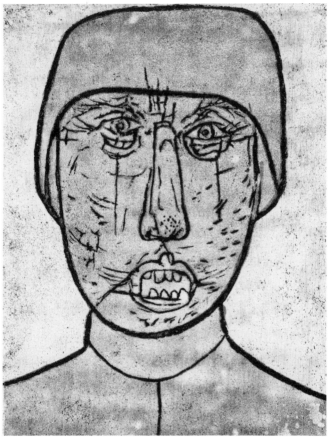

MAN IN A HELMET (#1) 1955. *Deep Etching and Aquatint. 7 7/8″ × 5³/₄″.*

Wallace believes that what happened at Dachau and Auschwitz is but the crowning achievement of modern man's "enormous arrogance". When the myth of unlimited opportunity for self or society leads the way then the means will always justify the end. "Progress" can then endorse and regulate almost any atrocity, from the concentration camps to utilizing a burned skull as a trophy of war.

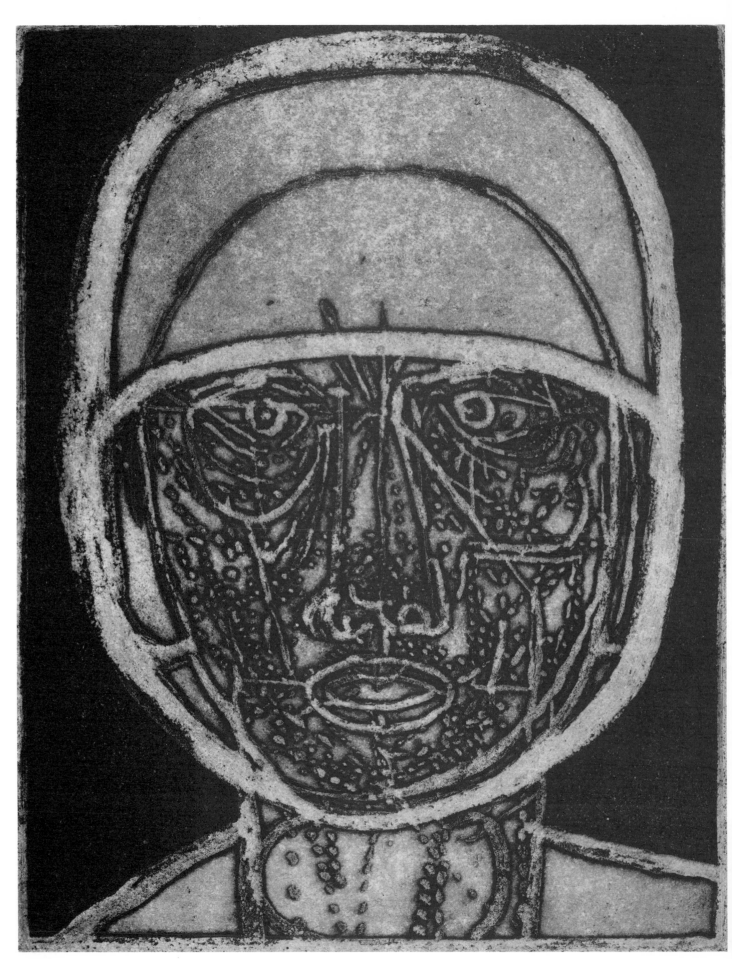

60 MAN IN A HELMET (#2) 1956. *Deep Etching and Aquatint. 11¾" × 9".*

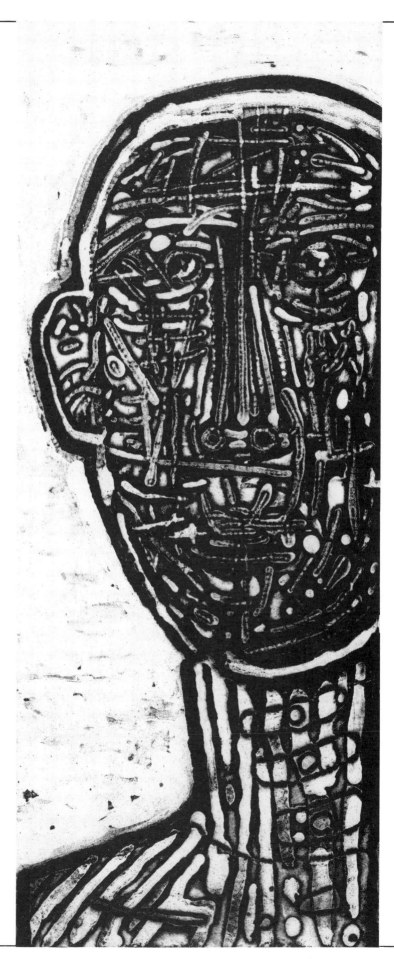

BURNT MAN 1961. *Deep Etching. 17½″ × 6 5/8″.*

Has mankind learned anything from this? Here is a popular historian's summation, composed weeks after the ending of the First World War:

Grand total of estimated cost in money, $249,000,000,000.

Was the cost too heavy? Was the price of international liberty paid in human lives and in sacrifices untold too great for the peace that followed?

Even the most practical of money changers, the most sentimental pacifist, viewing the cost in connection with the liberation of whole nations, with the spread of enlightened liberty through oppressed and benighted lands, with the destruction of autocracy, of the military caste, and of Teutonic kultur in its materialistic aspect, must agree that the blood was well shed, the treasure well spent. Millions of gallant, eager youths learned how to die fearlessly and gloriously.

Frederick A. March, History of the World War, 1918.

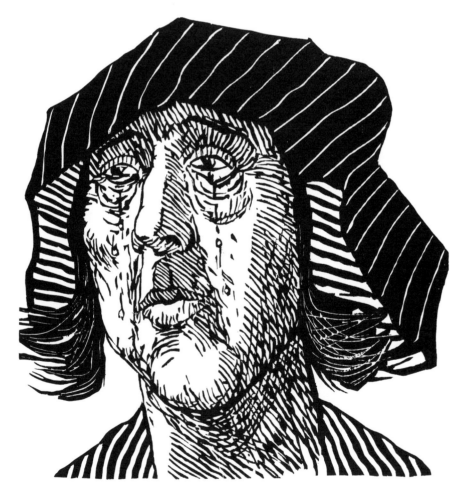

WEEPING WOMAN 1983. *Woodcut. 12″ × 13″.*

As civilization progresses, so do the casualties. In the First World War, seventeen million men from the combined forces perished. Civilian deaths from military action, massacre and starvation are listed at over twelve and a half million. These figures are dwarfed by statistics from the Second World War, where even non-combat incidents take on stunning proportions. When the bomb flattened Hiroshima, more than seventy-one thousand died instantly. The German death camps were responsible for the methodical executions of over six million prisoners.

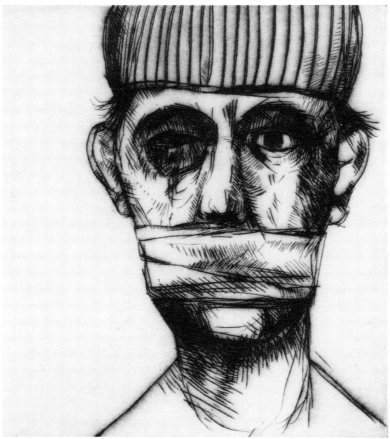

GAGGED MAN 1982. *Drypoint. 7 5/8" × 6 7/8".*

"What should I be now if it hadn't been for the war? I don't know, but something different from what I am. If the war didn't happen to kill you it was bound to start you thinking. After that unspeakable idiotic mess you couldn't go regarding society as something eternal and unquestionable, like a pyramid. You knew it was just a balls-up."

George Orwell, Coming up for Air

With justice maintaining, at best, its precarious "balancing act", the only real images are those of continuing vulnerability. Thus Wallace's artistic vision is Apocalyptic. In a universe of misplaced values, where the idea of a modern just society is nothing but a travesty, each inhabitant of the earth must share the same fate. All are victims.

LEGLESS MAN ON A STOOL 1975. *Welded Steel. 56" × 66" × 18".*

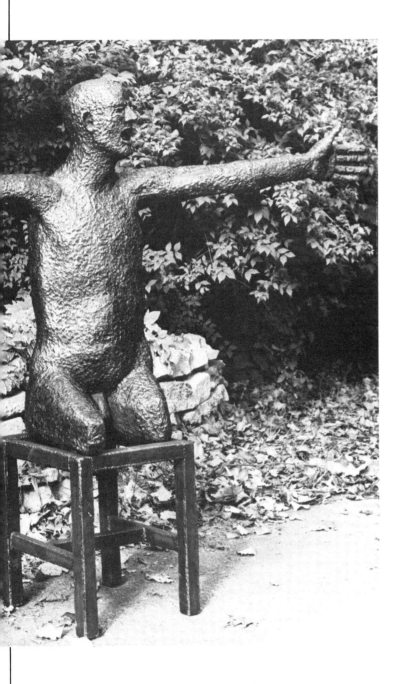

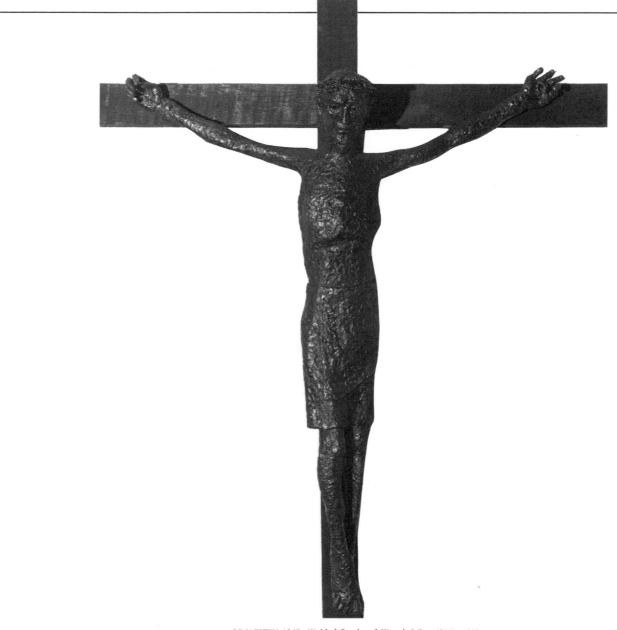

CRUCIFIX 1968. *Welded Steel and Wood. 54″ × 42½″ × 10″.*

Christ is the quintessential victim. We have seen this face before, but no image of death and decay in Wallace's art is quite as startling. Another prisoner of the human condition, he abides his suffering.

The sculpture is reminiscent of Grunewald's paintings of the Crucifixion. The Northern Renaissance master made the ugliness of the crucified Messiah the symbol of all the worldly sins Christ took upon himself. If we may view Wallace's work from this light, our sins have reached the point where it now appears inconceivable that this tiny, battered corpse, almost consumed by the immense cross, will rise. There is no spirit here, no divinity.

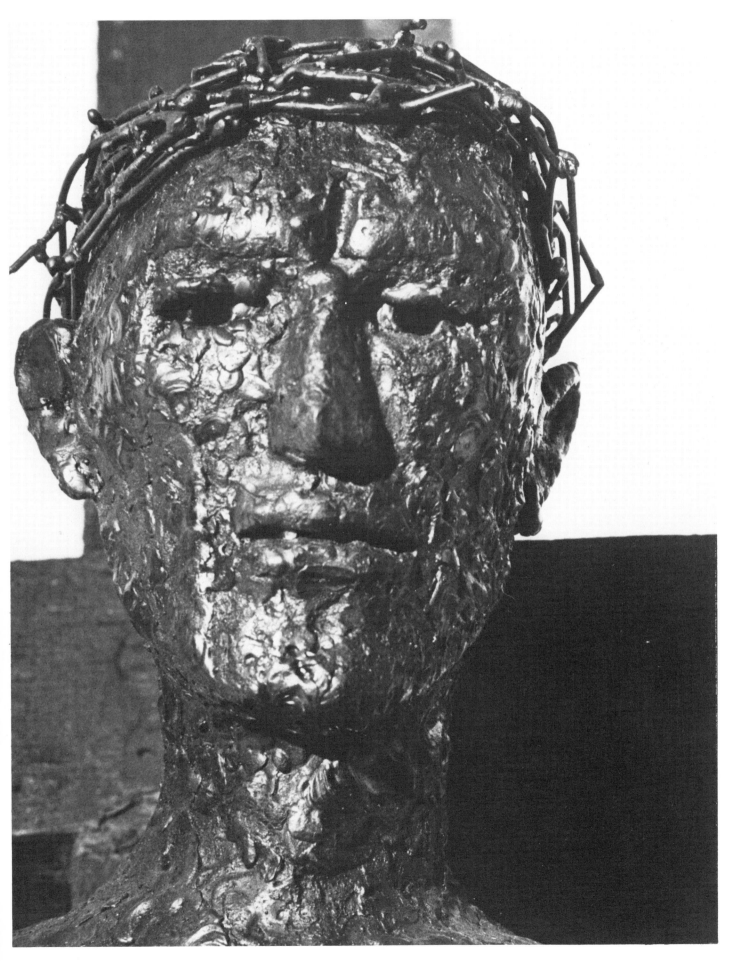

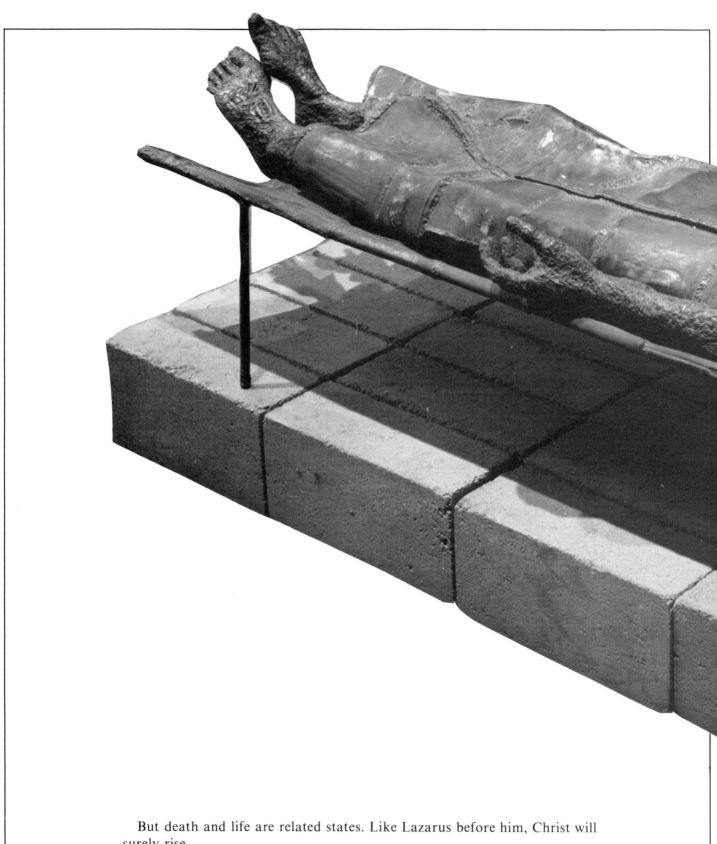

But death and life are related states. Like Lazarus before him, Christ will surely rise.

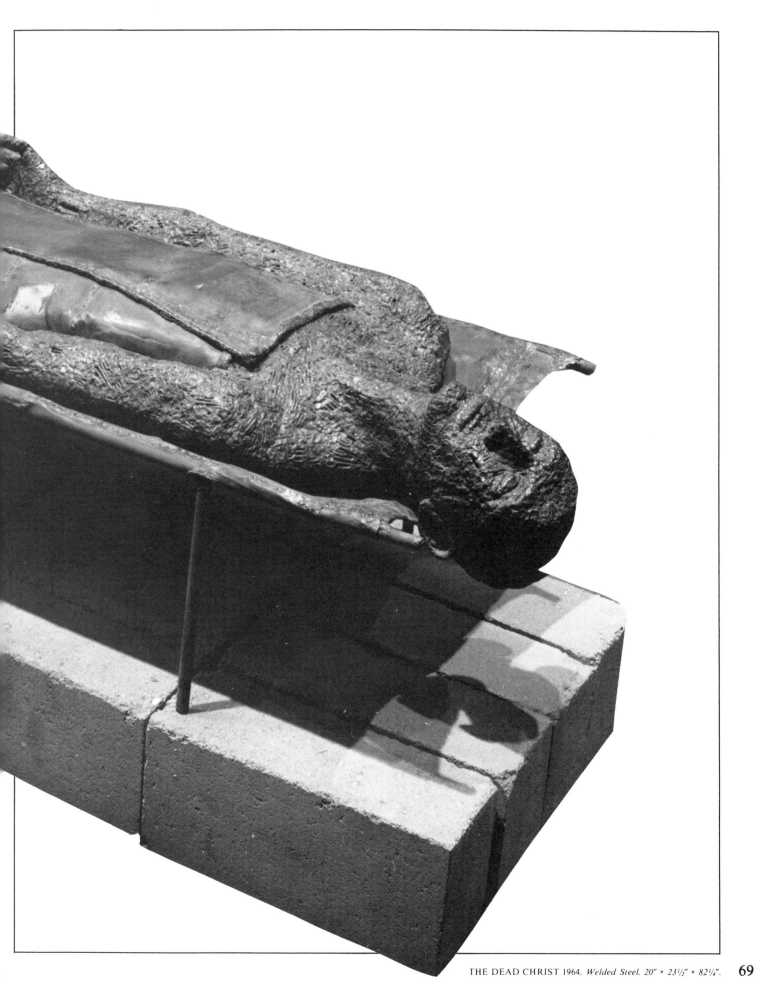

The anticipation we felt in "The Dead Christ" is once again apparent in "The Hanging Thief." Within the incredible, human shell of a prisoner who has finally finished his sufferings, the artist explores the force which animates life and death.

THE HANGING THIEF Detail.

THIEF HANGING IN BAPTIST HALLS

After a Sculpture by George Wallace

Amid the congratulations of summer,
polite vegetation, deans, a presbyterian sun,
brick minds quaintly shaped in gothic and glass,
here where the poise and thrust of speech
gleams like polished teak
I did not expect to see myself.

but there he hangs
shrugging on his hung lines,
soft as a pulped fruit or bird
in his soft suit of steel.

I wish he would not shrug
and smile weakly at me
as if ashamed that he is hanging there,
his dean's suit fallen off, his leg cocked
as if to run
or (too weak, too tired, too undone)
to do what can be done
about his nakedness.

Why should he hang there,
my insulting self, my deanship, all undone?

He dangles while the city bursts in green and steel,
black flower in the mouth of my speech:
the proud halls reel,
gothic and steel melt in the spinning sun.

—ELI MANDEL

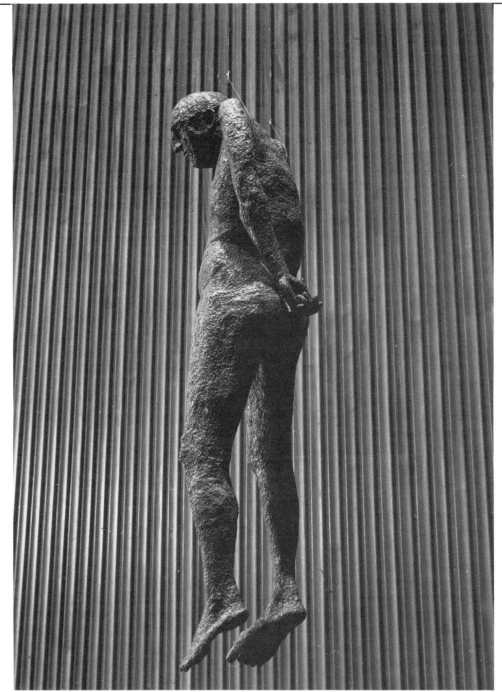

THE HANGING THIEF 1961. *Welded Steel. 73″ × 22″ × 15″.*

And he said unto Jesus, Lord, remember me when thou comest into thy kingdom.
And Jesus said unto him, Verily I say unto thee, To day shalt thou be with me in paradise.

Luke, Chapter 23, Verses 42 & 43

Death is the ambiguity which transforms the faces of the prisoners. "Death" neither mourns nor rejoices in his task: behind the impenetrable, Spartan helmet (fashioned from an automobile bumper) exists an enigmatic face. For those who make him unwelcome, he enters, the absolute, irrefutable warrior. Yet for the prisoners, he may appear as the welcome guest, with poppies in hand.

DEATH WITH FLOWERS 1965. *Welded Steel. 67" × 21 5/8" × 24 3/4".*

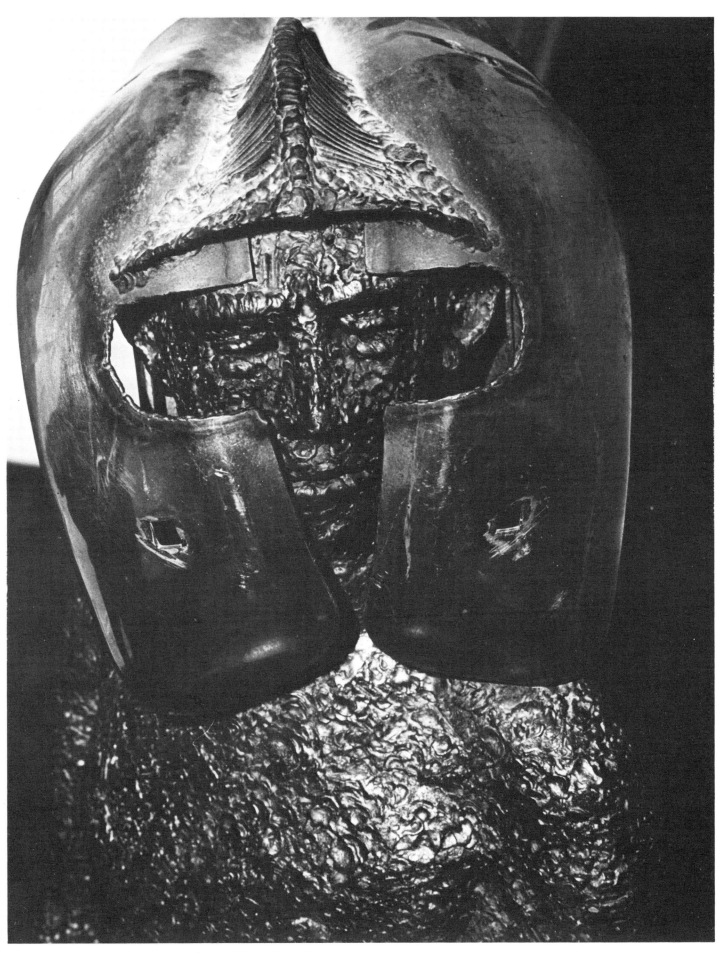

DEATH WITH FLOWERS. Detail.

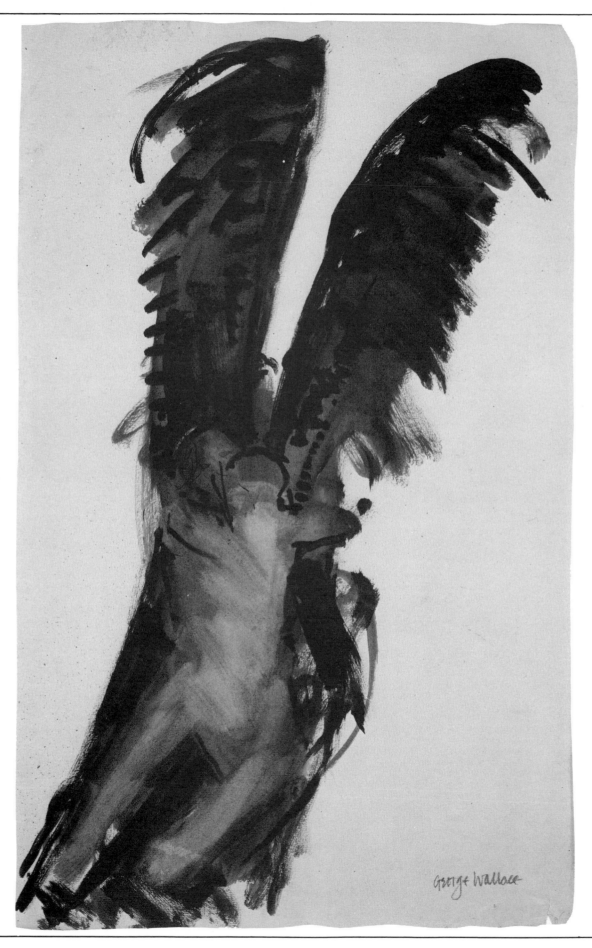

74 JACOB AND THE ANGEL 1977. *Drawing. 19½" × 12".*

ANGELS

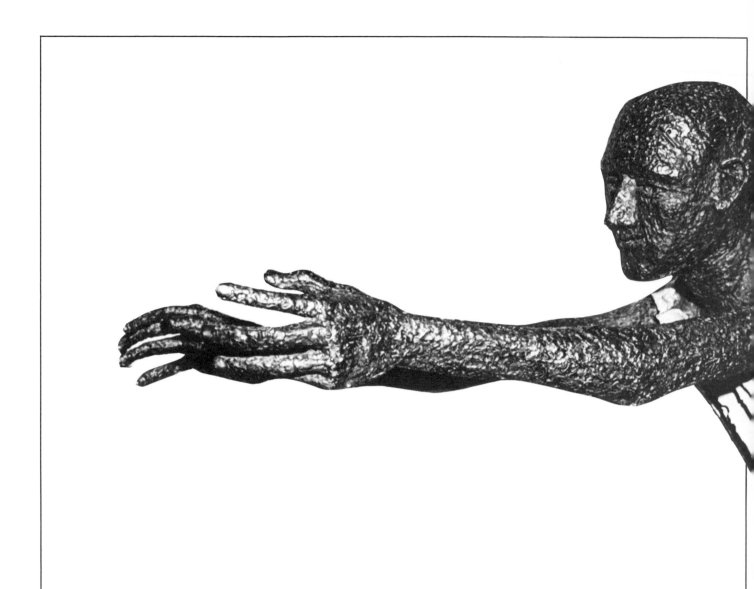

With arms outstretched, "The Benevolent Angel" brings hope and salvation. The angel's severe posture makes him comparable to representations of dieties in the sculpture and woodcuts of Ernst Barlach. The stance is so extreme it suggests that gravity and other earthly pressures are only restrictive to prisoners and other mortals.

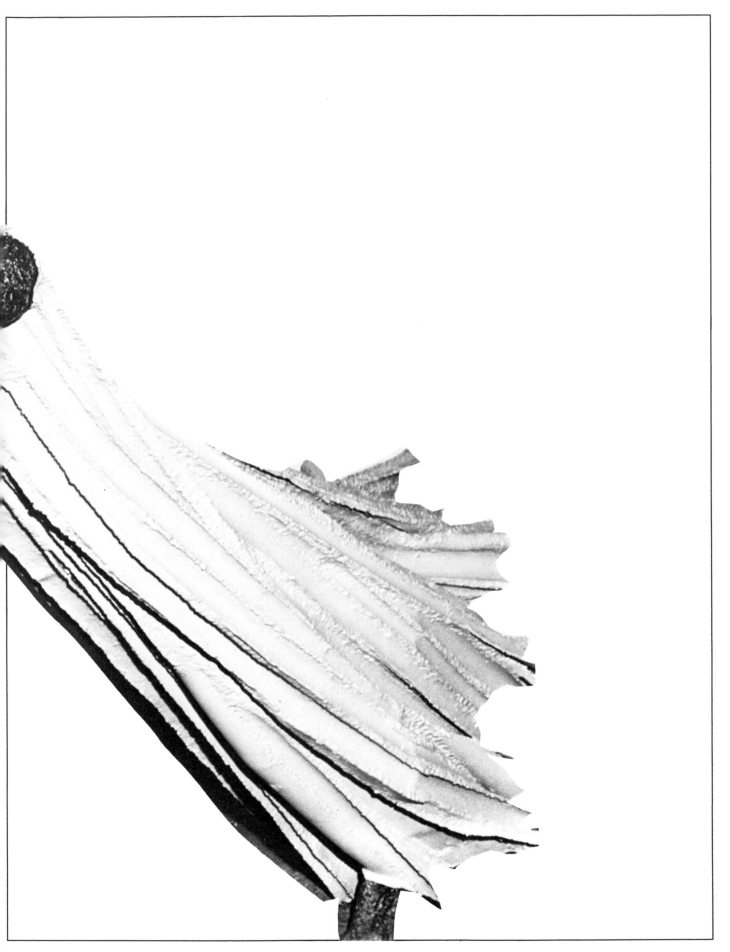

THE BENEVOLENT ANGEL 1963. *Painted Welded Steel. 61" × 29" × 76".*

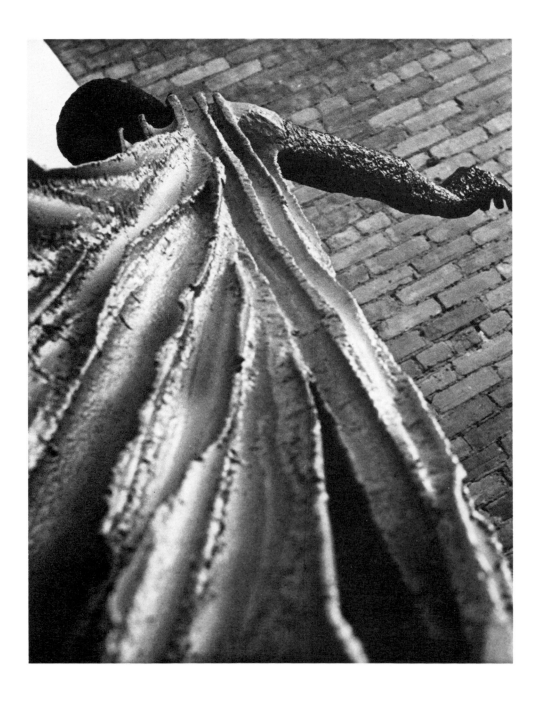

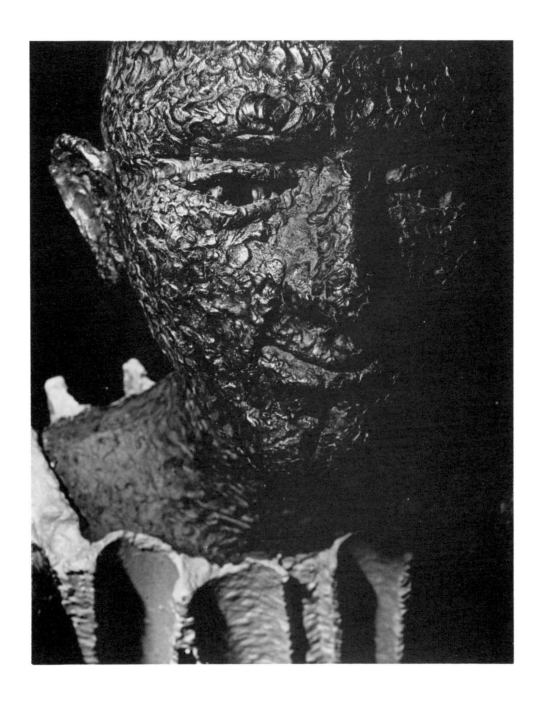

In general, the angels in George Wallace's art offer a marked contrast to both the inhabitants of the earth and the solid, static image of "Death". The angels are seen in movement, and movement provides the prime emblem for the other world of the soul. As God's messengers, they bring light and love to the sufferings of men. In the corten steel sculpture, "St. John and the Angel", John blissfully receives the descending angel. The angel's wings are severely shaped, resembling living pinnacles reaching upward to Heaven. Everything reflects motion. In the sculpture, "Jacob and the Angel", the divine struggle is transformed into a love embrace. Finally, in an etching entitled "Angel", a peaceful face with gigantic wings extending from its hair, glides gracefully through a dark world shedding its light.

Yet I am the necessary angel of earth,
Since, in my sight, you see the earth again,

Cleared of its stiff and stubborn, man-locked set,
And, in my hearing, you hear its tragic drone

Rise liquidly in liquid lingerings,
Like watery words awash; like meanings said

By repetitions of half-meanings. Am I not,
Myself, only half of a figure of a sort,

A figure half seen, or seen for a moment, a man
Of the mind, an apparition apparelled in

Apparels of such lightest look that a turn
Of my shoulder and quickly, too quickly, I am gone?

Wallace Stevens
from, "Angel Surrounded by Paysans"

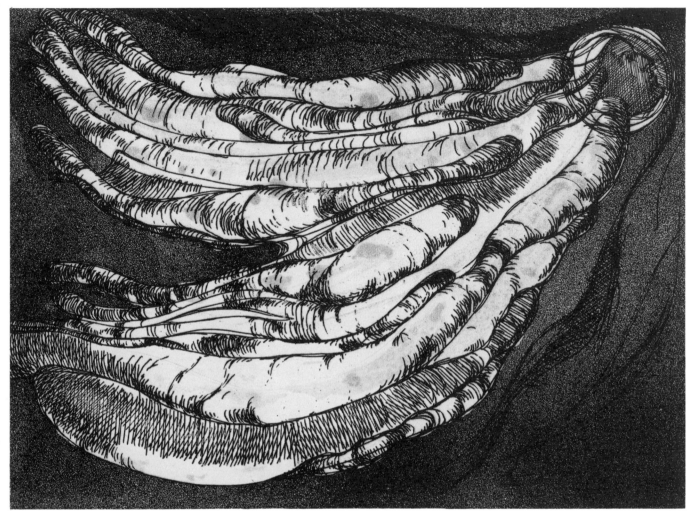

ANGEL 1969. *Aquatint and Etching. 17³⁄₄″ × 12³⁄₄″.*

From this initial working drawing to the finished sculpture, Wallace transformed an angular movement into a much stronger vertical structure, resembling the cross, and thus anticipating the Second Coming of Christ foretold in The Revelation.

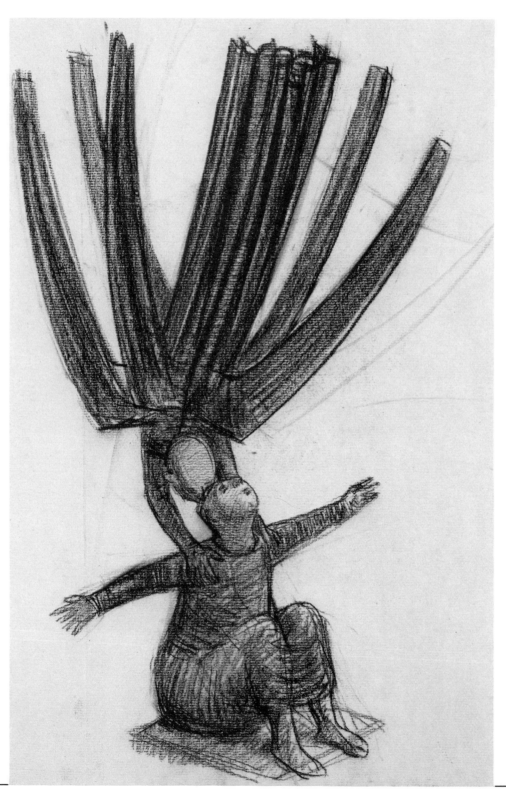

ST. JOHN AND THE ANGEL 1967. *Working Drawing. 15¼" × 10".*

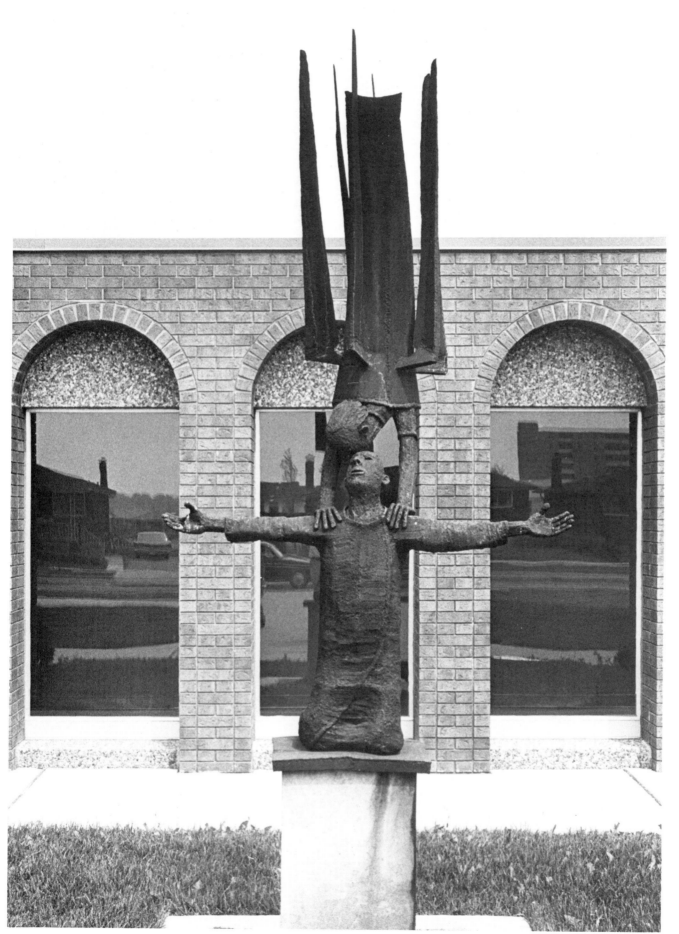

ST. JOHN AND THE ANGEL 1968. *Welded Corten Steel. C. 7' high.*

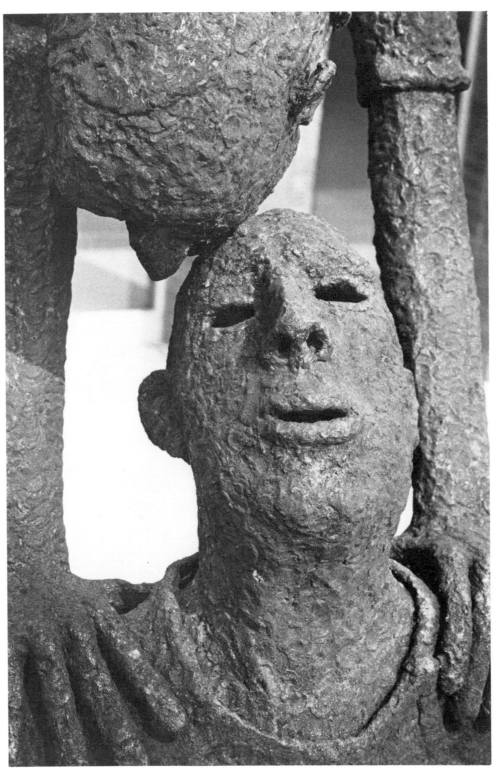

ST. JOHN AND THE ANGEL. Detail.

O sages standing in God's holy fire
As in the gold mosaic of a wall,
Come from the holy fire, perne in a gyre,
And be the singing-masters of my soul.
Consume my heart away; sick with desire
And fastened to a dying animal
It knows not what it is; and gather me
Into the artifice of eternity.

W.B.Yeats
from "Sailing to Byzantium"

Another encounter between man and angel is seen in the sculpture entitled "Jacob and the Angel". Here, Jacob is resolute to hold the angel — "I will not let thee go, except thou bless me" (Genesis 32, verse 26). The extended pose and the expression of his face reflects Jacob's painful yearning to know of the world beyond his own. Attempting to escape, the angel is rocked back, his wings helplessly fluttering in the air. He regards his struggling adversary in disbelief, as if he can't quite fathom the determination of this mortal being. But there is compassion in the angel, compassion for Jacob's suffering, and the combat turns into an embrace:

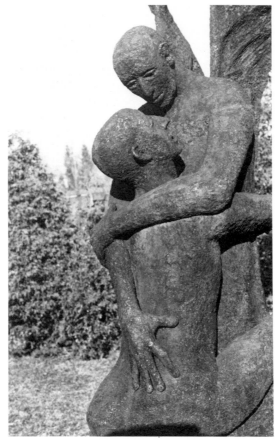

JACOB AND THE ANGEL. Detail.

And Jacob asked him, and said, Tell me, I pray thee, thy name. And he said, Wherefore is it that thou dost ask after my name? And he blessed him there. And Jacob called the name of the place Peniel: for I have seen God face to face, and my life is preserved.

Genesis 32, verses 29 & 30.

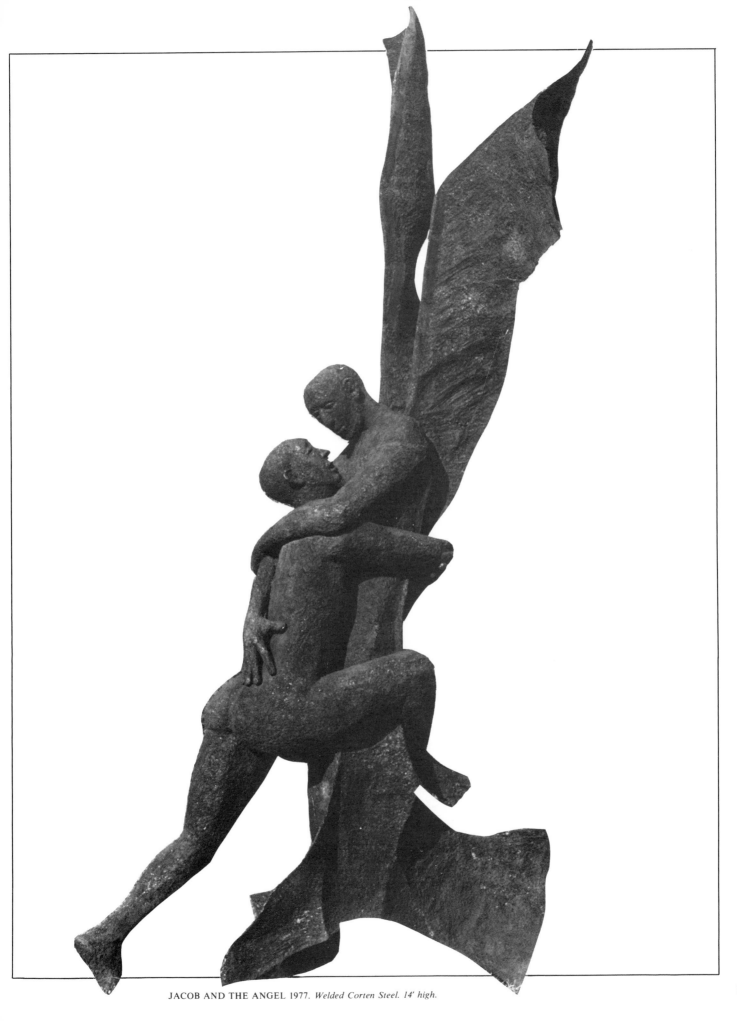

JACOB AND THE ANGEL 1977. *Welded Corten Steel. 14' high.*

JACOB AND THE ANGEL. Detail.

In 1966, George Wallace was commissioned by the Jewish Community Centre in Hamilton, Ontario, to create a sculpture entitled "Memorial to the Victims of the Holocaust". Initially, the committee for the centre requested an image of armed defence however, Wallace suggested something that conveyed the "strength and support of their heritage as Jews", that said, "we were supported in our death". The committee agreed to the artist's recommendations and the end result is a sculpture that contains both strength and compassion.

A man in long robes gently supports a fallen victim in a manner which is reminiscent of the previous encounters between angels and men. The victim, and not aspiring Daedalus, is closest to God. Neither extreme misery nor anger is expressed, only a sadness and a wisdom which enhances the verse, inscribed on the wall beside the work, more than any image of defence could.

These things do I remember: through all the years
Ignorance like a monster hath devoured
Our martyrs as in one long day of Blood.
Rulers have arisen through the endless years
Oppressive, savage in their witless power
Filled with a futile thought. To make an end
Of that which God hath cherished.

This compassionate image is not unlike many of the pictorial depictions of 'The Descent from the Cross' in western art. A powerful Christian symbol of suffering and support has been given a larger meaning.

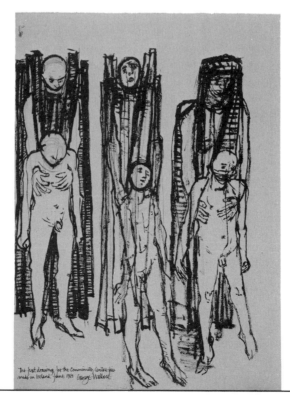

MEMORIAL TO THE VICTIMS OF THE HOLOCAUST 1966. *Working drawing. 15¾" + 11¼".*

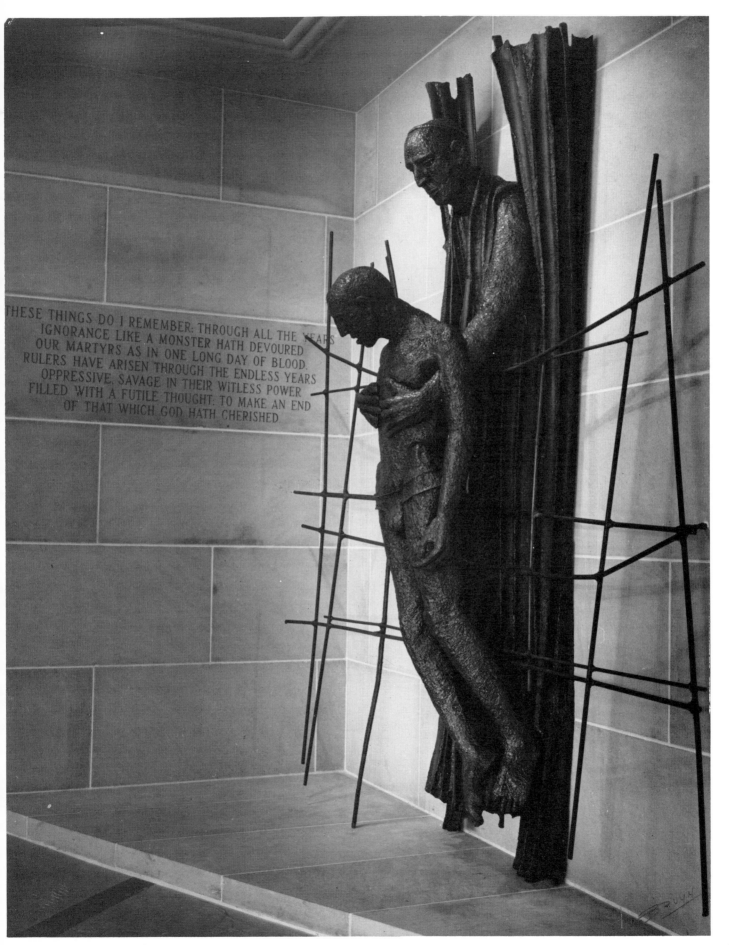

THESE THINGS DO I REMEMBER: THROUGH ALL THE YEARS
IGNORANCE LIKE A MONSTER HATH DEVOURED
OUR MARTYRS AS IN ONE LONG DAY OF BLOOD.
RULERS HAVE ARISEN THROUGH THE ENDLESS YEARS
OPPRESSIVE, SAVAGE IN THEIR WITLESS POWER
FILLED WITH A FUTILE THOUGHT, TO MAKE AN END
OF THAT WHICH GOD HATH CHERISHED

MEMORIAL TO THE VICTIMS OF THE HOLOCAUST 1966. *Welded Steel. 8' high.*

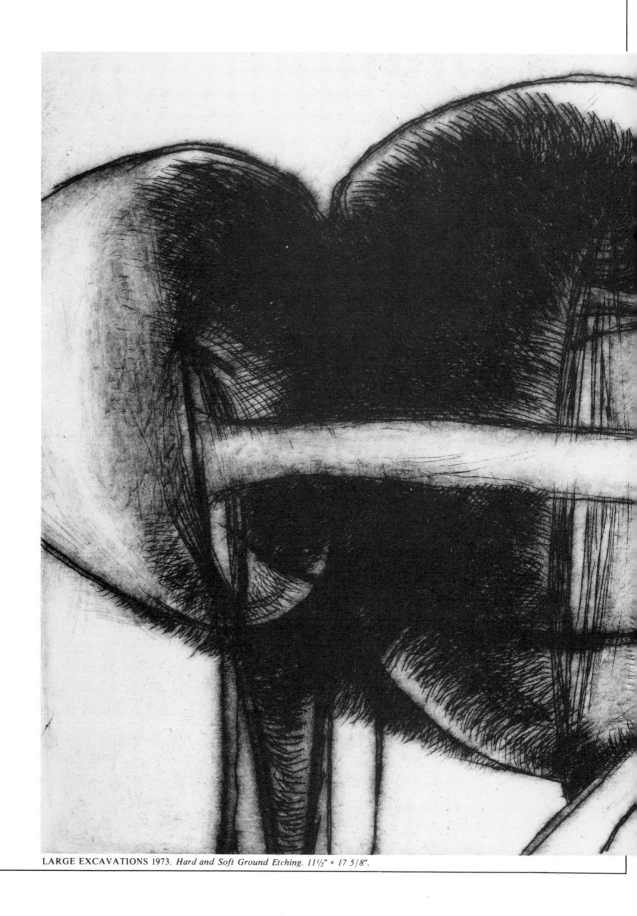

LARGE EXCAVATIONS 1973. *Hard and Soft Ground Etching. 11½″ × 17 5/8″.*

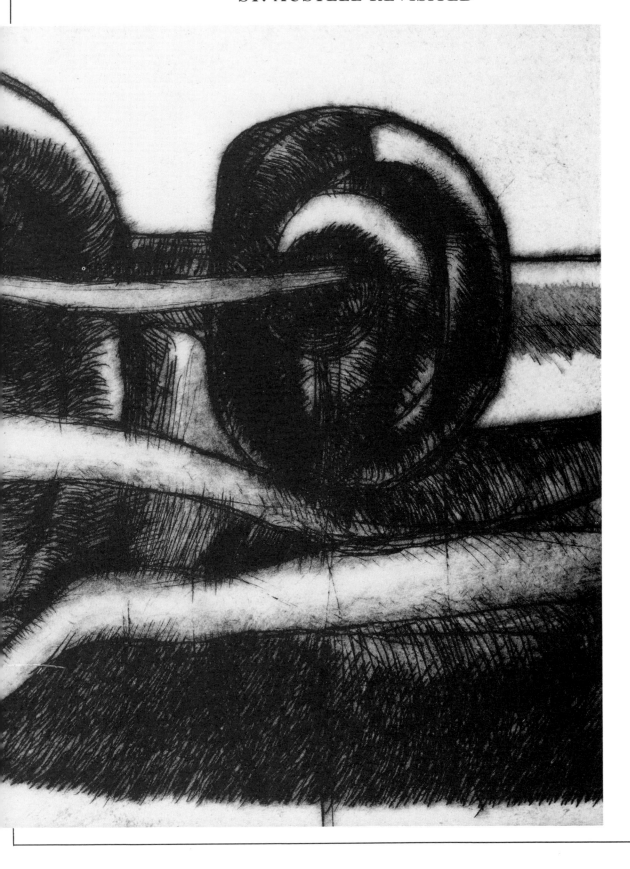

Beginning in 1971, George Wallace again turned to the most private images within his art, the mysterious forms of St. Austell. Gone are the severe, abstract designs. (By this point in time, the artist had arrived at the conclusion that abstract forms simply failed to "express enough". They tend to "be nice, neat and tidy: we don't inhabit such a world".) Most of the etchings contain both hard and soft grounds, and the monotypes have a thick, almost washed character. A different handling of both soft ground and drypoint gives these prints an impression of greater depth than the earlier landscapes, and Wallace has concentrated his focus on the forms within the earth itself. This is particularly true of the six etchings comprising the "St. Austell Portfolio" which the artist completed in 1972. Deliberately avoiding customary spatial references, Wallace offers a microscopic examination of shape.

TWIN FORMS 1972. *Etchings. 3¾″ × 2″.*

Initially, this can be quite disturbing for the spectator. The 'ground' has been quite literally cut out from under him, and he may find difficulty in securing a place to stand in relation to the image. Some shapes even appear to threaten because of their proximity. A close inspection illustrates how radically the artist has shifted his point of view. In the St. Austell and Redruth graphics from the mid 1950's, the images are of a dead world. The mystery surrounding some of these objects is contained in the dark shadows, the mystery of the mechanical ghost which tore the ground apart. With these more recent etchings, however, an existence slowly materializes from the battered earth; live organs clearly begin to take shape. In "Large Excavations", for example, the mines burrowed into the face of the cliff take on the appearance of the chambers of a gigantic heart. And the hard ground etching, "Excavations", from 1974, depicts fattened forms wrapped womb-like within themselves.

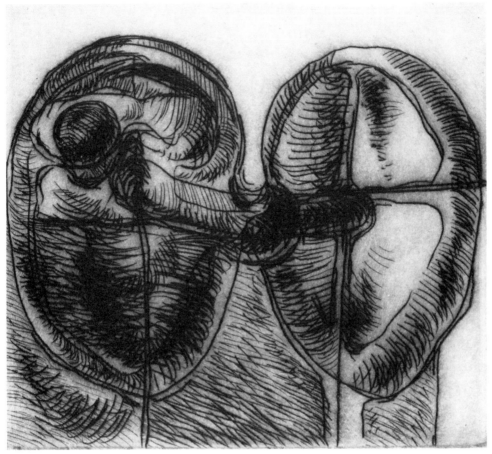

TWIN FORMS 1983. *Drypoint. 4¼″ × 4″.*

The uneasy impression of growth and movement gives these prints their special quality. Pod structures appear to quietly develop in several of the etchings from the portfolio; sexual shapes interact in the "Twin Forms" etchings. Everything remains silent and brooding, but these are soft materials, subject to slow but inevitable change. Even in this vulnerable world, a mysterious force is at work. Dead forms refuse to stop living.

EXCAVATIONS 1974. *Hard Ground Etching. 12 3/8″ × 8 1/8″.*

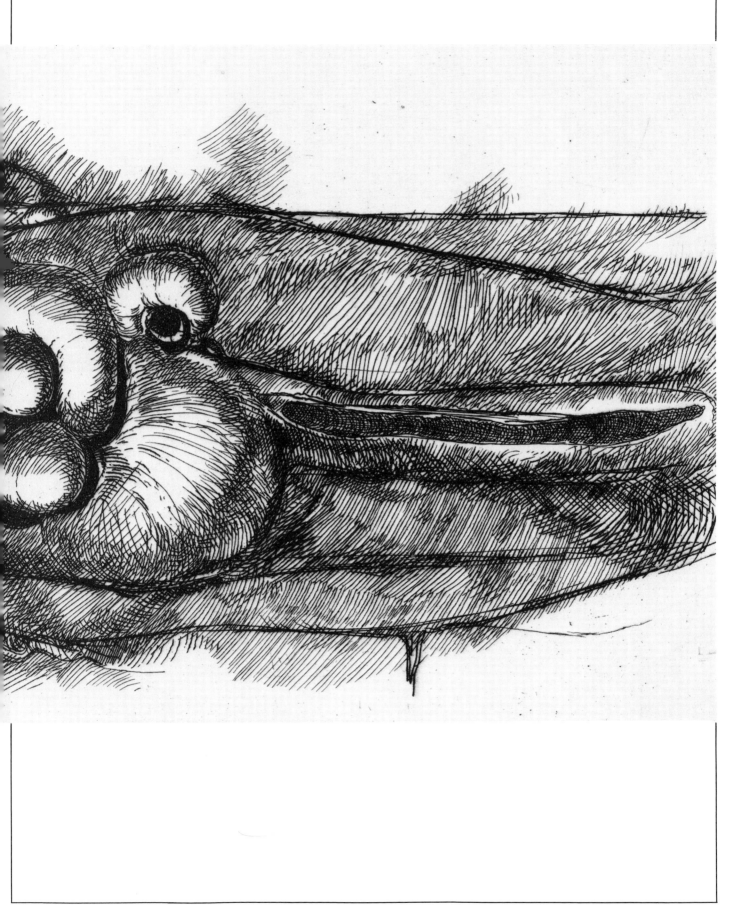

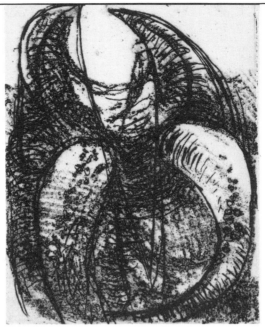

#1 from the set of SIX ST. AUSTELL ETCHINGS 1972.
Hard and Soft Ground Etching. 3 7/8″ × 3″.

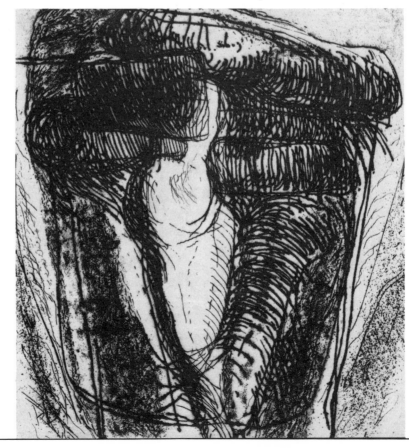

#5 from the set of SIX ST. AUSTELL ETCHINGS 1972. *Etching. 6½″ × 4 5/8″.*

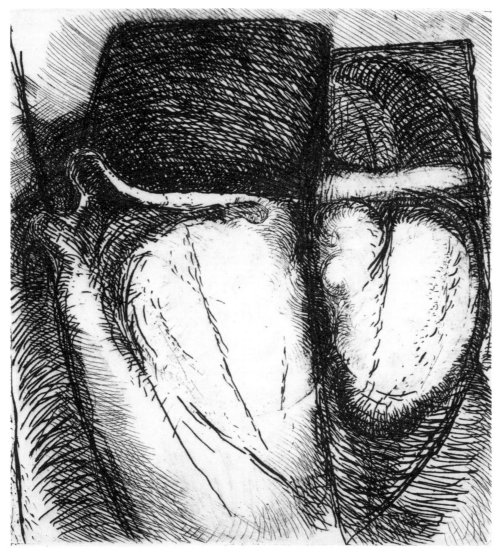

#6 from the set of SIX ST. AUSTELL ETCHINGS 1972. *Etching. 5 3/8″ × 4 7/8″.*

It would certainly be a mistake to view the temperament behind these landscapes as Arcadian. Wallace concentrates on the force and vitality of nature, but nature can just as easily have the effect of being sinister as being comforting. (In this light, one of the artist's favourite anecdotes is of some tourists who, equipped with photographic gear, ventured a bit too close to the breathtaking beauty of a recently active volcano. With cameras at the ready, they perished in the flames and lava.) The artist is drawn to the torn apart landscape of St. Austell just as he is drawn to the images of Peter, Lazarus or the prisoners. In every case, 'nature' is always stripped bare, permitting the same presence to emerge.

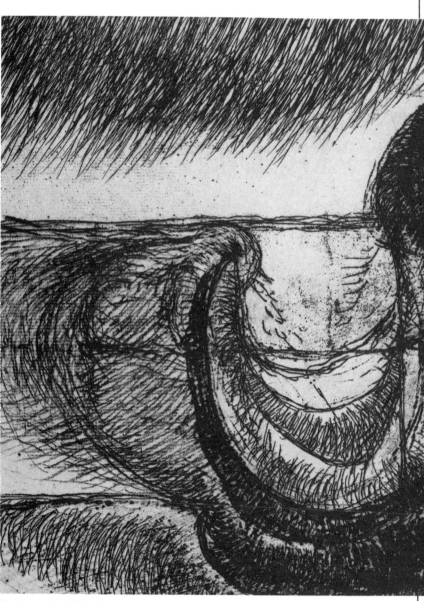

DARK LANDSCAPE 1983. *Drypoint. 9½″ × 14 5/8″.*

No matter what he depicts, the images of George Wallace's art are those of vulnerability and suffering. It is not, however, a world without hope. Redemption comes through caring and compassion; the angels are our guides to escape this theatre of man-made misery. And regardless of how deeply we become ensnared in the systematic destruction of ourselves and our planet, a timeless mechanism is always present.

In Wallace's art, this deepest force becomes visible. Call it a universal clockwork, or the hidden hand of God. His art gives form to the presence that brings death to life and life to death. Like the "Hanging Thief", dangling on his lines, they are suspended states.

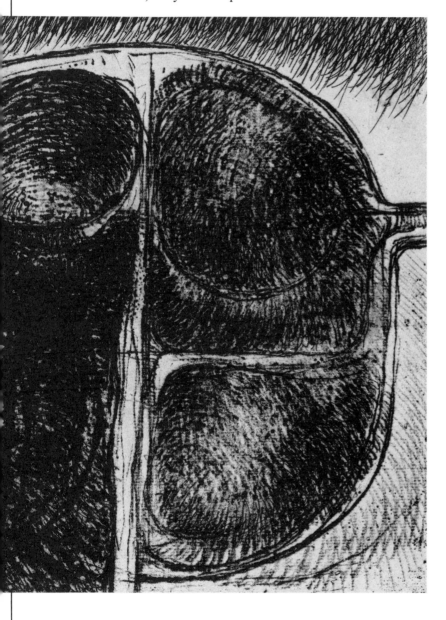

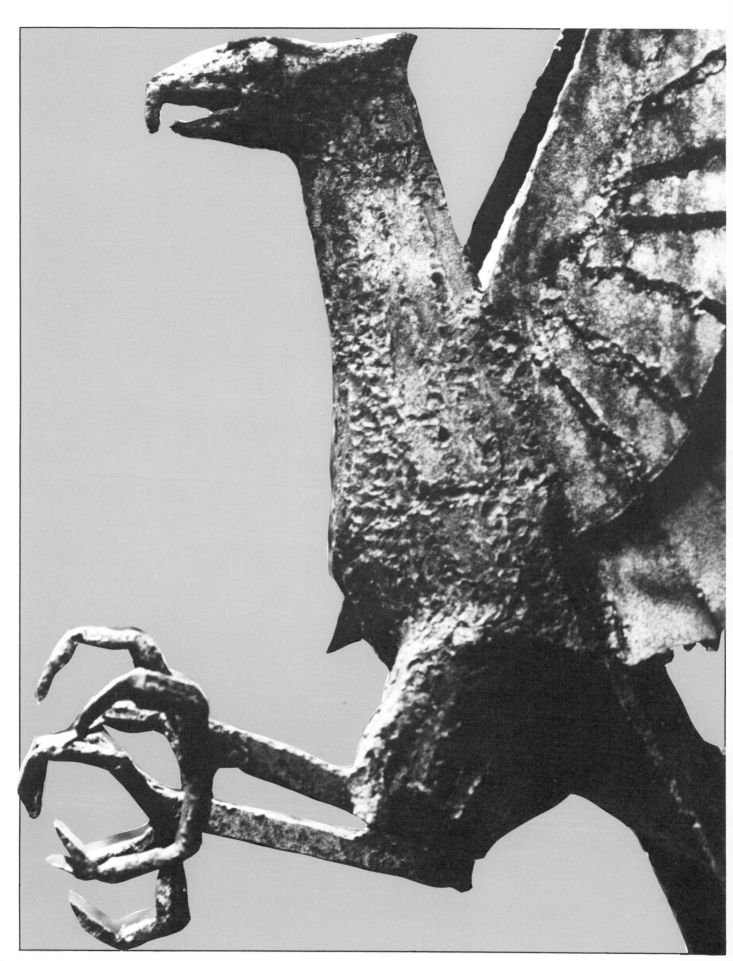

102 Detail of MAN RELEASING EAGLES from p. I.

BIOGRAPHY, COLLECTIONS, AND EXHIBITIONS

BIOGRAPHY

George Wallace was born in Sandycove, South County, Dublin, Ireland, on June 7, 1920. He was educated at Trinity College, Dublin (1939-44), and the West of England College of Art, Bristol (1946). In 1957, he took permanent residence in Canada, becoming a citizen several years later. Since 1960, George Wallace has been a professor of Fine Arts at McMaster University in Hamilton, Ontario, Canada.

He was made a member of the Royal Canadian Academy in 1975. Wallace has had one man exhibitions in Montreal, Toronto and Hamilton. His works are included in the collections of the Art Gallery of Hamilton, McMaster University and Mohawk College, Hamilton, Ont., the Montreal Museum of Fine Art, Montreal, Quebec, and the Art Gallery of Ontario, Toronto.

COLLECTIONS (SCULPTURE AND DRAWINGS)

McMaster University:
"Man Releasing Eagles", "Daedalus" and "Death with Flowers".

Mohawk College (Hamilton):
"Educational Experience" and "Educational Experiment"

Halton County Court House, Milton Ont:
"The Balancing Act".

Art Gallery of Hamilton:
"The Apple Pickers".

MacDonald Stewart Art Centre, Guelph, Ont:
"The Dead Christ".

St. John the Divine Parish, London, Ont.:
"Crucifix" and "St. John and the Angel".

Jewish Community Centre, Hamilton, Ont.:
"Memorial to the Victims of the Holocaust".

Collection of Cynthia and John McMenemy:
"Lazarus"

Private Collection:
"Jacob and the Angel"

Collection of Rabbi Baskin:
"Memorial to the Victims of the Holocaust" (Drawing).

Collection of Wayne Allan:
"Lazarus" (Monotype).

Collection of Greg Peters:
"Design for a Wall Relief on the Theme of Technological Progress" (Drawing), "Jacob and the Angel" (Drawing).

SOLO EXHIBITIONS

1957 Waddington Gallery, Montreal, Quebec.
1958 Gallery of Contemporary Art, Toronto, Ont.
1969 University of Guelph, Guelph, Ont.
1980 "Sculpture and Prints by George Wallace", Nov. 19, 1980 — Jan. 26, 1981. Brock University, St. Catherines, Ont.
1983 "George Wallace; Sculpture and Graphics", March 30 — April 30, 1983. Hamilton Artist's Inc., Hamilton, Ont.

GROUP EXHIBITIONS

1947 "Royal Hibernion Academy", Dublin, Ireland.
1949 Annual exhibition of the Royal Hibernion Academy, Dublin.
1950 "Contemporary Irish Painting" an exhibition organized by the Cultural Relations Committee of Ireland shown in Providence R.I., Boston and Ottawa.
1950 Annual exhibition of the Royal Hibernion Academy, Dublin.
1950 Annual exhibition of the Royal West of England Academy, Bristol.
1950 Annual Irish exhibition of Living Art, Dublin.
1951 Annual exhibition of the Royal West of England Academy, Bristol.
1951 Annual Irish exhibition of Living Art, Dublin.
1952 Annual exhibition of the Royal West of England Academy, Bristol.
1952 Annual Irish exhibition of Living Art, Dublin.
1952 "London Group Exhibition", London, England.
1953 "Contemporary Irish Art" an exhibition organized by the Cultural Relations Committee of Ireland, shown in Wales.
1953 Annual "London Group" exhibition, London.
1955 "Contemporary Irish" an exhibition organized by the Cultural Relations Committee of Ireland, shown in West Germany.
1955 Annual Irish Exhibition of Living Art, Dublin.
1955 "Royal West of England Academy Exhibition", Bristol.
1956 Annual Irish Exhibition of Living Art, Dublin.
1957 "Royal Hibernion Academy", Dublin, Ireland.
1961 "Hamilton Art Gallery Annual Exhibition", Hamilton, Ont.
1962 "Hamilton Art Gallery Annual Exhibition", Hamilton, Ont.
1963 "Hamilton Art Gallery Annual Exhibition", Hamilton, Ont.

1964	"Hamilton Art Gallery Annual Exhibition", Hamilton, Ont.
1965	"Hamilton Art Gallery Annual Exhibition",Hamilton, Ont.
1966	"Hamilton Art Gallery Annual Exhibition", Hamilton, Ont.
1967	"Sculpture Canada '67", Toronto, Ont.
1967	"Hamilton Art Gallery Annual Exhibition", Hamilton, Ont.
1968	"McMaster University Faculty Show", Hamilton, Ont.
1968	"Hamilton Art Gallery Annual Exhibition", Hamilton, Ont.
1969	"Hamilton Art Gallery Annual Exhibition", Hamilton, Ont.
1970	"Hamilton Art Gallery Annual Exhibition", Hamilton, Ont.
1971	"Hamilton Art Gallery Annual Exhibition", Hamilton, Ont.
1972	"Hamilton Art Gallery Annual Exhibition", Hamilton, Ont.
1973	"Hamilton Art Gallery Annual Exhibition", Hamilton, Ont.
1977	"McMaster University Faculty Show", Hamilton, Ont.
1979	"McMaster University Faculty Show", Hamilton, Ont.

PUBLICATIONS

"Drawings by Otto Dix". *The National Gallery of Canada Journal*, No. 4, January, 1975.

The Artist's Zoo. Holt, Rinehart & Winston, Toronto, 1970.

The Artist's Workshop. Holt, Rinehart & Winston, Totonto 1971.

Sailing Ships — Themes in Art. Holt, Rinehart & Winston, Toronto, 1972.

"A Biographical Note". *George Wallace: Sculpture and Graphics* (catalogue) Hamilton Artists' Inc., March, 1983.

PHOTOGRAPHIC CREDITS

Herman DeBruyn:
"Memorial to the Victims of the Holocaust", "The Dead Christ" and "The Hanging Thief" (Full View).

James Chambers:
Photograph of George Wallace (1983), "The Apple Pickers", "Death with Flowers" (Full View) and "Man on a Broken Cot".

David Nasby:
"The Hanging Thief" (Details), "Man on a Cot", "Daedalus", "Educational Experience", "Crucifix" and "St. John and the Angel".

Dan Pilling:
"Man Releasing Eagles" (Full View and Details), "The Benevolent Angel", "Educational Experiment", "Lazarus" (Details), "Lazarus Risen from the Dead" and "Death with Flowers" (Detail).

George Wallace:
"The Balancing Act", "Lazarus" (Full View), "Legless Man on a Stool" and "Jacob and the Angel".

SOURCES OF LITERARY EXTRACTS

Atwood, Margaret:
"A Place: Fragments", from *The Circle Game*, 1966. Copyright 1966, Margaret Atwood. Reprinted by permission of House of Anansi Press Ltd., Toronto, Canada.

Beckett, Samuel:
Molloy and *The Unnamable*, from *Three Novels*, 1959. Copyright 1955 & 1959, Samuel Beckett. Reprinted by permission of Calder & Boyars Ltd., London.

Mandel, Eli:
"Thief Hanging in Baptist Halls", from *Black and Secret Man*, 1964. Copyright, The Ryerson Press, 1964. Reprinted by permission of Eli Mandel.

Orwell, George:
Coming up for Air, 1939. Copyright the estate of the late Sonia Brownell Orwell and Martin Secker & Warburg Ltd. Reprinted by permission of A.M. Heath & Company Ltd., London.

Plath, Sylvia:
"Lady Lazarus", from *Ariel*, 1965. Copyright 1965, Ted Hughes. Reprinted by permission of Faber and Faber Ltd., London.

Stevens, Wallace:
"Six Significant Landscapes" and "Angel Surrounded by Paysans", from *The Palm at the End of the Mind: Selected Poems and a Play, by Wallace Stevens*, 1971. Holly Stevens, ed. Copyright 1967, 1969 & 1971 by Holly Stevens. Reprinted by permission of Alfred A. Knopf, Inc., New York.

Yeats, W.B.:
"Byzantium" and "Sailing to Byzantium", from *The Collected Poems of W.B. Yeats*, 1950. Copyright Michael B. Yeats, Anne Yeats and Macmillan, London, Limited. Reprinted by permission of A.P. Watt Ltd.

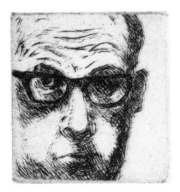

SELF PORTRAIT 1973. *Etching. 1 5/8" × 1¾".*